LEICA M

THE EXPANDED GUIDE

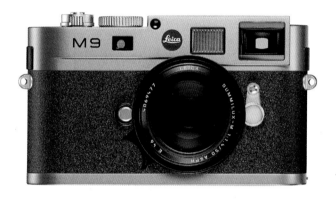

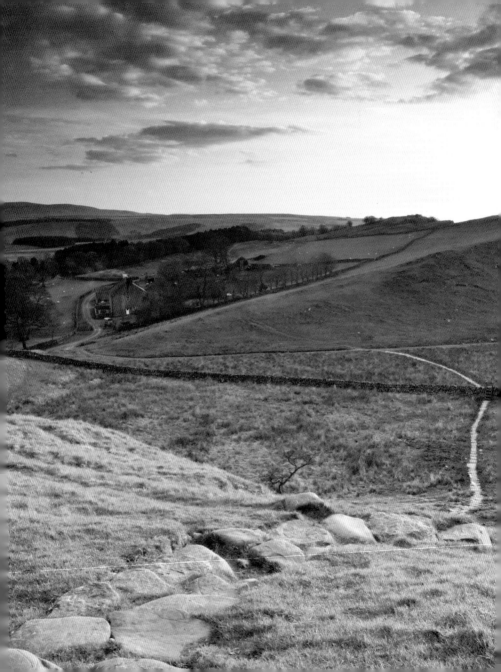

LEICA M9

THE EXPANDED GUIDE

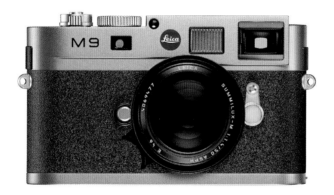

David Taylor

AMMONITE
PRESS

First published 2011 by
Ammonite Press
an imprint of AE Publications Ltd
166 High Street, Lewes, East Sussex, BN7 1XU, UK

Text © AE Publications Ltd, 2011
Images © David Taylor, 2011
Product photography © Leica, 2011 (unless otherwise
indicated)
Copyright © in the Work AE Publications Ltd, 2011

ISBN 978-1-90770-806-0

British Library Cataloging in Publication Data: A catalog
record of this book is available from the British Library.

Editor: Ian Penberthy
Series Editor: Richard Wiles
Design: Richard Dewing Associates

Typefaces: Giacomo
Color reproduction by GMC Reprographics
Printed and bound in China by Hing Yip Printing Co. Ltd

« PAGE 2
Last light over the
Hadrian's Wall Path,
United Kingdom.

» CONTENTS

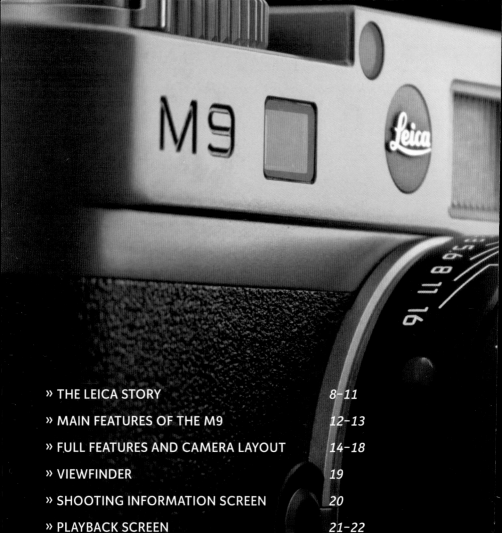

Chapter 1
OVERVIEW

1 OVERVIEW

The M9 is the first full-frame digital camera from Leica. It follows a long and illustrious line of cameras back to the birth of 35mm photography in 1920s Germany.

› Oskar Barnack

The story of Leica is the story of the small-format camera itself. That story was begun by a German optical engineer named Oskar Barnack, head of development for the camera company Leitz in Wetzlar in the early 20th century.

Oskar Barnack was a keen photographer, but was in poor health and found the heavy plate cameras of the day difficult to handle. His ambition was to create a camera that would dispense with the cumbersome glass exposure plates. Instead, the camera would use a standard roll film of a much-reduced format, and the resulting photographs would be enlarged in the darkroom at a later stage.

In 1912, Barnack created a 35mm movie camera. In 1914, he succeeded in producing a small-format camera, the Ur-Leica. This had a negative size of 24 x 36mm, achieved by doubling the size of contemporary cinema film of 18 x 24mm.

Although the onset of the First World War delayed the launch of the first Leica (the name being a contraction of Leitz Camera) until 1925, Leica's chief, Ernst Leitz, then authorized the production of 1,000 of the cameras, a not inconsiderable risk. (By 1932, there would be 90,000 of the cameras in use, and by 1961, this had increased to 1,000,000.)

The birth of the small-format camera revolutionized photography, enabling a new spontaneity and pushing photojournalism, in particular, to new levels of intimacy and immediacy. For his achievements, Oskar Barnack enjoys a well-justified reputation as the "father of 35mm photography."

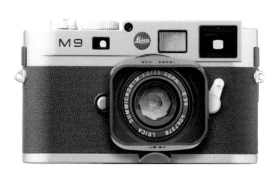

THE LEICA M9 «

› Leica

The launch of the Ur-Leica at the Leipzig Spring Fair in 1925 was followed very quickly by the first small-format enlarger, known as FILAR, and, in 1926, by the first 35mm projector, which was launched under the name ULEJA.

In 1930, the Leica I Schraubgewinde was launched. It had an interchangeable lens system based on a 39mm-diameter screw thread, known as the Leica Thread Mount (LTM). In addition to the 50mm standard lens, a 35mm wide-angle and a 135mm telephoto lens were also available.

The Leica II was introduced in 1932, and featured a built-in rangefinder coupled to the lens-focusing mechanism, as well as a separate viewfinder. At this point, photographers could choose from a total of seven different lenses with the standardized screw-thread mounting. It was also in 1932 that the 100,000th Leica camera was produced.

From 1933 to 1957, Leica introduced a number of models of Leica III, each incorporating new refinements. The first model added slow shutter speeds down to 1 second, while the IIIa, the last model for which Oskar Barnack was wholly responsible, provided the 1/1000 sec. shutter speed.

In 1954, the Leica 250 (another of the III series) was introduced. It was nicknamed the "Reporter" and contained a 10-meter film, enabling 250 exposures to be made without the need to reload the camera. This model was also fitted with a spring motor and became the camera of choice in reconnaissance aircraft used by the German air force.

› The M-Mount

In 1954, the Leica M3 was introduced at the Photokina show in Germany. This new camera eschewed the M39 screw lens mount in favor of a bayonet fitting. The benefit of a bayonet mount over a screw fitting is that it allows a more rapid mounting and removal of a lens. In addition, the fitting is more secure. Other innovations included a combined focusing rangefinder and viewfinder in one window and a double-stroke film-advance lever.

The M3 was an immediate success. When production ceased in 1966, over 220,000 units

THE LEICA M7　　　　　　　　　　　　❯❯
The last (to date) film-based M-mount camera.

had been made. It is still the highest selling M mount camera Leica has ever produced. Moreover, it is still a desirable camera today. Clean units in good condition are still in high demand, and they fetch good prices on auction web sites like eBay.

The photographer most associated with Leica is Henri Cartier-Bresson, co-founder of the Magnum Photo picture library. Many of Cartier-Bresson's iconic photographs from the 1950s and 1960s were created using a Leica and a 50mm lens. Such is his association with Leica that, as a tribute, the company produced the unique Leica M6 "Cartier-Bresson no. 22-8-1908," with the date of the photographer's birth used as the serial number.

The M3 was followed by the M1 and the M2, both cut-down versions of the M3, and then over a span of 40 years by other M-series cameras, culminating in the M7 of 2002. Although the basic concept of the M7 differs little from the M3, modern technology such as TTL (through the lens) exposure and an option of aperture priority or manual exposure brought the M-series up to date.

› Leica in the Digital Age

During the lifetime of the M-mount, Leica has introduced a series of other camera standards. The most significant was the R-mount, first used on the 35mm Leicaflex camera introduced in 1964. The Leicaflex failed to find a market in competition with Japanese SLR systems and was superseded by the R3 and the R-series of cameras in 1976. The final camera in the range, the R9 was in production from 2002 until 2009.

It was the R8 and R9 that allowed Leica to introduce an element of digital technology to their camera lineup. In 2004, the Digital Modul R 10-megapixel digital back was announced. Compatible with the R8 and R9, the Digital Modul R is the only digital back ever produced for a 35mm camera system.

In 2006, Leica announced the release of the M8, the first digital M-mount camera. The M8 uses a 10.3-megapixel Kodak KAF-10500 CCD image sensor. Despite teething problems, the M8 was well received. In answer to some of those initial problems, Leica released the M8.2 in 2008.

The one issue that was not addressed by the M8.2 was the sensor. It was smaller than "full-frame" (lenses fitted to the M8.2 have a crop factor of 1.33), and Leica claimed that fitting a larger sensor into an M-mount body was technically impossible. However, on 9th September, 2009, Leica announced the arrival of the M9, a true "full-frame" camera with an 18.5-megapixel Kodak KAF-18500 sensor. Despite its price tag, the M9 has been enthusiastically embraced by Leica owners and is seen as a worthy continuation of the work of Oskar Barnack and Ernst Leitz.

WYNCH BRIDGE »
The 1830 Wynch Bridge chain suspension bridge over the River Tees, England.

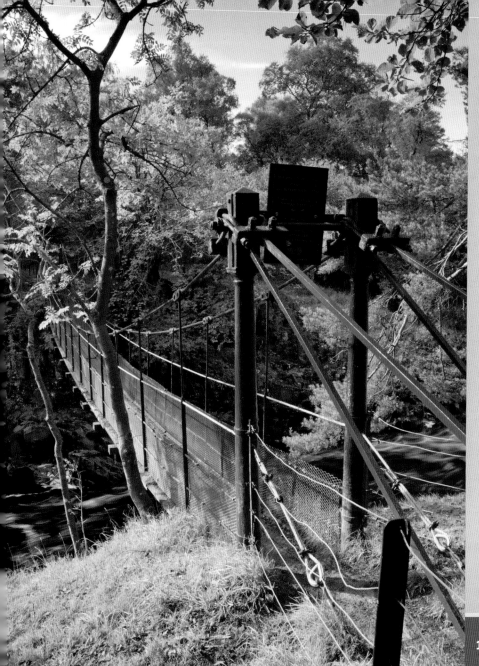

1 » MAIN FEATURES OF THE LEICA M9

Body

Dimensions (W x D x H): 5.47 x 1.46 x 3.15in (139 x 37 x 80mm)
Weight 20.64oz (585g) with the battery and memory card

The camera chassis is a two-piece design using a highly stable magnesium alloy. The exterior is finished with a black synthetic leather coating. The top panel and base plate have a solid brass core with silver or black chromium plating.

Sensor and processor

18 effective megapixels (18.5 in total) on a 23.9 x 35.8mm RGB CCD sensor equivalent to 35mm "full frame." Pixels have a pitch of 6.8 x 6.8 μm. Offset micro-lenses are used near frame corners to reduce effects of vignetting. The sensor has no anti-alias filter for improved sharpness.

File types and sizes

The M9 supports the Adobe DNG RAW format, recorded at the native resolution of 5212 x 3472 pixels. JPEG files can be recorded at five different resolutions, 5212 x 3472 (18MP), 3840 x 2592 (approx. 10MP), 2592 x 1728 (approx. 4.5MP), 1728 x 1152 (approx. 2MP), and 1280 x 846 pixels (approx. 1MP). Two levels of JPEG compression are available, Fine and Basic.

LCD Monitor

The monitor on the rear of the M9 is a 2.5in color TFT LCD with a resolution of 230,000 pixels. The monitor is used for all menu functions and image review. Brightness can be adjusted manually via the M9 menu system.

Memory Card

Compatible with SD cards up to 2GB or SDHC cards up to 32GB. Formatting uses FAT/ FAT 32 standard.

Lens and focusing

The M9 uses the Leica M standard. Modern Leica lenses are identified by an inbuilt 6-bit sensor in the lens mount. This information is used in flash exposure control with compatible flashguns and for optimizing picture data. Focusing is achieved manually employing the distance scale on the lens or by using a "split image" focus confirmation in the viewfinder. Lenses within the focal length range of 16–135mm can be used with the M9.

Shutter

The M9 uses a vertical focal-plane microprocessor-controlled metal blade shutter. In aperture priority mode, the shutter speed range is steplessly adjustable between 32 seconds and

1/4000. In manual mode, the shutter speed is selectable between 4 seconds and 1/4000 in ½ EV steps. A bulb setting with a maximum length of 240 seconds is also available.

Exposure

The M9 uses a center-weighted "through the lens" (TTL) metering system. Light is measured from the 1st curtain shutter blades. TTL metering is also available with compatible SCA-3000/2 flashguns. The metering range at normal operating conditions is EV 0 to 20. Exposure is confirmed in the viewfinder by under/correct/overexposure indicators. ISO sensitivity can be user set between ISO 80 (in "pull mode") and ISO 2500.

Flash

The Leica M9 has no built-in flash but is compatible with Leica M-TTL flashguns mounted on the integral hotshoe. Flash sync speed is 1/180 sec. Manual flash can be used between bulb and 1/180 sec. Auto slow sync available (1/focal length of the mounted lens in seconds—6-bit coded lenses only). Flash compensation +/- 3.0 EV in ⅓ EV steps. 1st or 2nd shutter priority user definable.

Viewfinder

Eyepiece is set to -0.5 diopter. Supplementary correction lens available between -3 and +3 diopter. Viewfinder enlargement (0.68x) for all lenses. Viewfinder bright-line frames automatically adjust for lens used. Parallax correction is automatically applied. Split and superimposed image combined and shown as bright field in the center of the viewfinder. Shooting and memory card information displayed.

Software

Adobe Lightroom 3 available for download after user registration of the M9 on the Leica Camera AG homepage.

1 » FULL FEATURES AND CAMERA LAYOUT

FRONT OF CAMERA

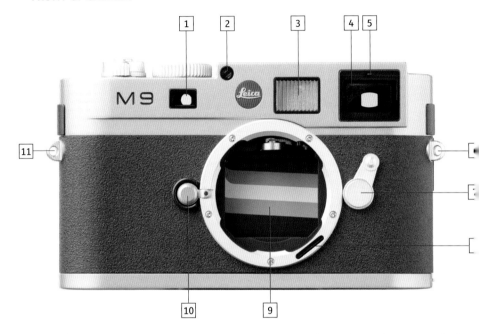

FRONT OF CAMERA

1	Distance meter window	6	Carrying strap eyelet
2	Brightness sensor	7	Image field selector
3	Illumination window for viewfinder bright line frames	8	Lens identification sensor
4	Viewfinder window	9	Shutter blades
5	Self-timer LED	10	Lens release button
		11	Carrying strap eyelet

BACK OF CAMERA

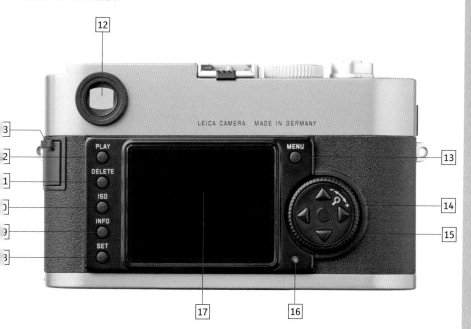

BACK OF CAMERA

12	Viewfinder ocular	18	SET button
13	Menu button	19	INFO button
14	Setting dial	20	ISO button
15	Direction buttons	21	Delete button
16	Memory card status LED	22	Play button
17	LCD monitor	23	USB port cover

TOP OF CAMERA

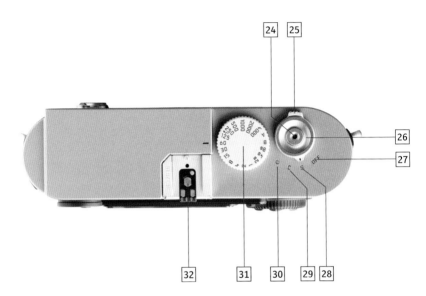

TOP OF CAMERA

24	Cable-release socket	29	Main switch—Continuous shot position
25	Main switch	30	Main switch—Self-timer position
26	Shutter release button	31	Shutter speed dial
27	Main switch—Off position	32	Flash hotshoe
28	Main switch—Single shot position		

BOTTOM OF CAMERA

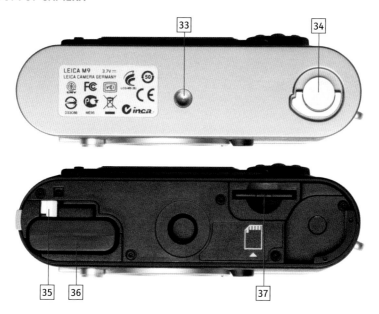

BOTTOM OF CAMERA

33 Tripod thread

34 Bottom cover release

BOTTOM OF CAMERA (without bottom cover)

35 Battery locking slider

36 Battery compartment (with battery)

37 Memory card slot (with memory card)

1 » FULL FEATURES AND CAMERA LAYOUT

LEFT AND RIGHT SIDE OF CAMERA

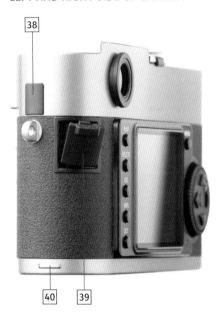

LEFT SIDE OF CAMERA	RIGHT SIDE OF CAMERA
38 Carrying strap anti-scratch pad	**38** Carrying strap anti-scratch pad
39 USB port cover (open)	
40 Bottom cover locking clip	

» VIEWFINDER

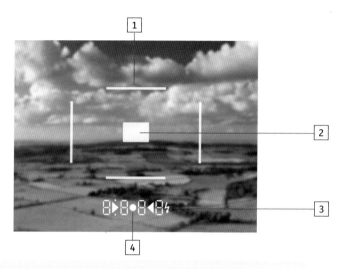

VIEWFINDER

1. Bright line frame (50mm shown)
2. Focus guide
3. Flash symbol
4. Status display (used in different ways depending on the camera setting)

1 » SHOOTING INFORMATION SCREEN

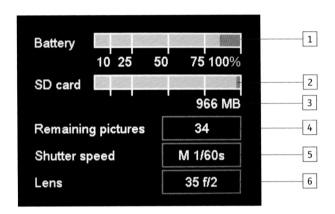

SHOOTING INFORMATION SCREEN

1 Battery status

2 Memory card usage bar

3 Memory card space remaining
 in megabytes

4 Number of pictures available

5 Currently set shutter speed

6 Coded lens information
 (focal length & set aperture)

» PLAYBACK: NORMAL MODE

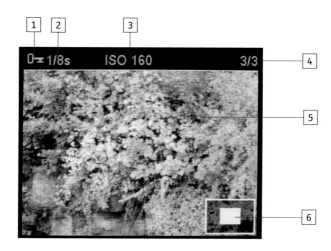

PLAYBACK: NORMAL MODE

1	Delete protection symbol (only if set)
2	Shutter speed
3	ISO setting
4	Picture number/Total number of pictures taken
5	Current picture
6	Enlargement level/Position of section displayed

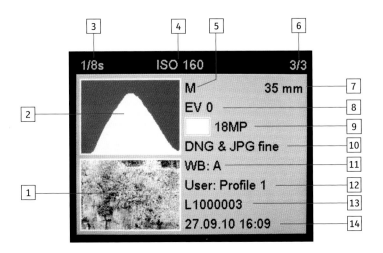

PLAYBACK: HISTOGRAM DISPLAY

1	Current picture
2	Luminance histogram
3	Shutter speed
4	ISO setting
5	Exposure mode
6	Picture number/Total number of pictures taken
7	Coded lens focal length

8	Applied exposure compensation
9	Resolution
10	File format (and level of compression)
11	White balance
12	User profile name
13	File number
14	Date/time

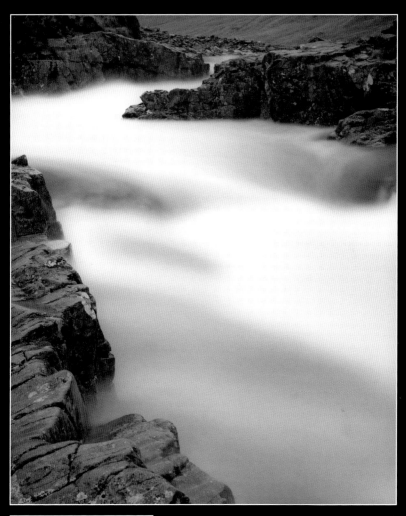

Settings
› Lens: 35mm
› Shutter: 25 sec. (bulb)
› Aperture: f/8

LIGHTROOM ⌃
The Leica M9 is paired with Adobe Lightroom. This software is a powerful tool for black & white conversion, including effects such as split toning, as used here.

Chapter 2
FUNCTIONS

2 FUNCTIONS

The Leica M9 is the latest camera in a line that stretches back to the 1920s. This heritage has informed the philosophy behind the design of the M9. Anyone familiar with previous Leica M-series cameras will be able to pick up the M9 and quickly use it with confidence.

The M9 is a deceptively simple camera, particularly in comparison with a modern DSLR. It can be used as a purely manual camera, one in which exposure must be set by you. However, the M9 also boasts a degree of automation that will help you get the best out of any shooting situation.

This chapter will guide you through the basics of using your Leica M9 straight from the box. The rest of the book will show you how to get the best out of your camera as a creative tool as you progress on your photographic journey.

THE LEICA M9
The M9 combines the simple styling of its film-based ancestors with modern digital technology.

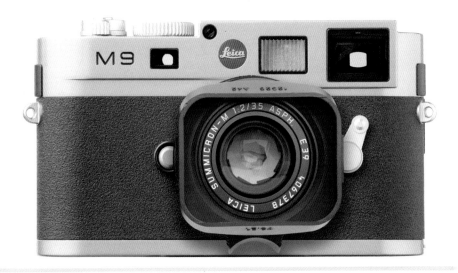

» CAMERA PREPARATION

› Registering your M9

Unlike most cameras, the M9 is not supplied with any software. However, once you've registered your M9 on the Leica web site, you will be able to download and use Adobe Lightroom. Not only that, but there are other benefits as well, such as receiving alerts when camera firmware updates are available.

Register your camera at *https://owners. leica-camera.com/en/login*.

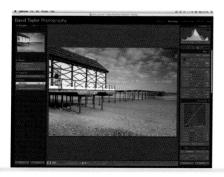

› Attaching the strap

The Leica M9 is a significant financial investment, one that should be protected as much as possible from accidental damage. Using the supplied camera strap will allow you to carry the camera around your neck and avoid the potential disaster of accidentally dropping it.

To attach the strap to the camera, move the plastic guard up and away from the metal loop on one end of the strap. This can be quite a tricky operation, best achieved by holding onto the metal loop and pulling firmly on the plastic guard.

Once you have freed the metal loop, twist it around in the strap until two prongs become visible. Now feed one of the prongs through the strap eyelet on the M9 and open up the loop so that it can be fed in and onto the eyelet. Once the loop is in the eyelet, align the prongs with the plastic guard and push the guard down firmly so that the prongs are covered once more. Repeat with the eyelet on the other end of the camera.

ADOBE LIGHTROOM **«**
Leica has not developed its own RAW converter so encourages you to use Lightroom instead.

› The bottom cover

M-series film cameras differ from most other film cameras by not having a hinged back to access the film chamber. Instead, a bottom cover needs to be removed and film loaded from below. The cameras were designed this way to make them structurally stronger and less prone to mechanical failure. The digital M-series cameras carry on this tradition. The bottom cover is removable, allowing access to both the memory card slot and battery compartment.

REMOVING THE BOTTOM COVER �

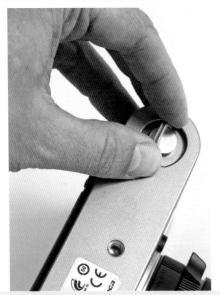

The one drawback to this arrangement is that once the M9 is mounted on a tripod, it is almost impossible to change either the battery or memory card without disturbing your setup. Therefore, it is worth developing the habit of starting your photographic day by fitting the camera with an empty memory card and a fully-charged battery.

Removing and replacing the bottom cover

Ensure that the M9 is switched off. Rest the camera carefully upside down. With the camera front facing toward you, turn the locking ring to the left until there is no resistance. Unhook the bottom cover from the locking clip and pull it free.

To replace the bottom cover, hook it back onto the locking clip and lower it down onto the bottom of the camera. Secure it by turning the locking ring to the left as far as the stop, and then push the ring flat into the bottom cover.

> ### Warning!
>
> *If you remove the bottom cover with the M9 switched on, the following warning message will be displayed on the LCD:*
> ***Attention Bottom cover removed***

› Mounting and removing a lens

Switch off your M9 before adding or removing a lens. Hold the camera so that the front is facing you. When you first receive your M9, a body cap should be fitted onto the lens mount. This protects the shutter blades and sensor inside the camera from damage and dust. Replace the body cap when your camera is not in use and there is no lens attached. To remove the body cap, press down on the lens release button and turn it to the left until it comes free.

Remove the rear protection cap from the lens. Hold the lens by the fixed ring and align the red index mark on the lens barrel with the lens release button on the M9. Push the lens into the lens mount so that the lens and camera connect. Turn the lens gently clockwise until it clicks into place. To remove the lens, reverse the procedure. Replace the body cap on the M9 and the rear cap on the lens if neither is to be used again immediately.

Tips

Dust will inevitably build up on the sensor over time. This can be exacerbated when changing lenses out of doors, particularly if windy. Try to use your body to shelter your camera as much as possible in these conditions.

Using your lens' smallest apertures (so maximizing depth of field) will make more dust apparent. Try to use precise focusing and the largest aperture possible for the required zone of sharpness.

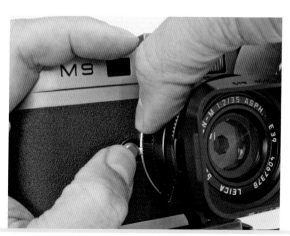

REMOVING THE LENS »
To remove a lens, press down on the release button and turn the lens counterclockwise.

2 » POWERING THE M9

› Battery charging

The battery used by the Leica M9 is a unique-fit lithium-ion (li-ion) cell. The advantage of li-ion batteries is their slow loss of charge and their lack of "memory"—this means they can be charged without the need to discharge them fully first.

To charge up the M9 battery, connect the supplied 14-663 battery charger to the AC power cord and insert the plug into a wall receptacle. Slot the battery as far as it will go into the charger with the battery contacts facing into the charger. The battery is shaped so that it can only be fitted into the charger one way. If there is excessive resistance, do not force the battery farther. Instead, remove the battery and try again.

When charging begins, a green LED on the charger will flash. Once the battery has reached 80% charge, a yellow LED will light up. The battery can be used at this point and will hold enough charge for approximately 250 shots. Once the battery reaches 100% charge, the green LED will stop flashing and be lit continuously. A fully charged battery will be able to power approximately 350 shots. To completely charge a fully depleted battery, will take approximately 210 minutes.

Once the battery is charged, turn off the power supply, unplug the charger from the wall receptacle, and remove the battery by sliding it from the charger.

Notes:
The battery charger can be used abroad (100–240v AC 50/60hz) with a suitable plug adapter and does not require a voltage transformer.

Both the LEDs flashing together when charging first begins indicates a charging error. The operating temperature of the battery charger is between 32° and 95°F (0° and 35°C). If these conditions are not met, move the charger to another location and try again. If the problem persists, contact your local Leica dealer.

A brand-new battery will not be able to hold a full charge unless it has been charged and discharged fully two or three times.

There is a second backup battery inside the M9 that saves data such as time and camera settings. This battery is not user accessible and is recharged when the main battery is inserted. The charge for the backup battery lasts for approximately three months. Once it is fully depleted, the battery will require 60 hours to recharge; however the M9 does not need to be switched on during this time.

› Inserting and removing the battery

Turn off the M9 before inserting or removing the battery. Detach the bottom cover as described on *page 28*. Slot the battery into the battery compartment with the battery terminals facing toward the front of the camera. Push the battery down until the white locking slider clicks into place and secures the battery.

To remove the battery, push the locking slider to the right (with the camera facing away from you) and pull the battery carefully from the compartment.

The battery charge level is displayed onscreen during image playback when the INFO button is pressed.

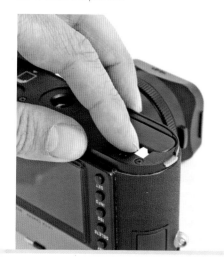

› Good power management

Inevitably, using your M9 will drain the batteries. However, you can maximize the time between recharges with a few simple techniques.

First, keep the use of the LCD to a minimum, since this is probably the biggest drain on the battery's power. Set the menu options you require before a shoot and leave them set for the day's shooting. Don't spend hours checking each image as you shoot with a view to editing in the field. A quick check of focus is all you need before moving onto the next shot.

Secondly, don't overshoot—a few good photos are better than a memory card full of mediocre ones.

Finally, follow Leica's recommended routine to keep your battery in top condition. A full discharge of power and then a full recharge every 25 charging cycles will "exercise" the battery and enable it to retain its maximum charge.

REMOVING THE BATTERY **«**
Pushing the white lock lever to the right allows the battery to be removed.

The M9 is compatible with SD memory cards up to 2GB in capacity, or the newer SDHC cards up to 32GB. Formatting uses FAT/FAT 32 standard, which is readable by both Windows PCs and Apple Macs.

Installing a memory card

1) Switch off the M9 and remove the bottom cover (see page 28).

2) If the SD card has a lock switch, move it to the unlock position. When switched to lock, you will still be able to view any images on the card, but you will not be able to write new images to it or format the card.

3) Insert the memory card into the slot in the base of the camera. The metal contacts on the card should face toward the rear of the M9.

4) Slide the card down until it clicks positively into place. To remove the card again, push it down slightly until it is released by the locking mechanism and pull it gently out of the slot.

5) Replace the bottom cover.

Note:

Battery							▓▓▓
		10	25	50		75	100%
SD card							
							966 MB
Remaining pictures				34			
Shutter speed				M 1/60s			
Lens				35 f/2			

Pressing INFO in shooting mode, will display an information screen showing battery power and number of shots remaining, as well as details about shutter speed and attached lens.

Warning!

Do not remove the memory card if the camera is switched on.

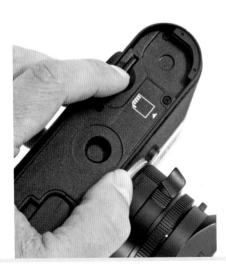

INSERT THE MEMORY CARD　　　**«**
Push the memory card into the slot in the base of the camera until it clicks into place.

» BASIC CAMERA FUNCTIONS

To set the shooting and playback options, the Leica M9 uses a combination of mechanical dials and button controls. The mechanical controls, such as the shutter speed dial, will be covered in more detail later in this chapter.

There are six option buttons arrayed around the LCD, which are used to access the M9's onscreen menus. To the left of the LCD are four direction buttons arranged in a circular "joypad" surrounded by a setting dial. These controls are used to navigate around the various menus.

Throughout the rest of this book, the direction buttons will be shown as ◀ ▲ ▼ ▶ and the setting dial as ⭕ . Any words in bold type are options visible on a menu screen. The option buttons, such as MENU, will be capitalized.

› Switching the camera on

The M9 main switch has four settings. If set to OFF, the camera is entirely inactive. Pushing the switch one position to the left sets the M9 to S, or single-picture mode. When set to C, the camera is in continuous picture mode. Finally, set to ⓧ , the M9 is in self-timer mode (see Drive Mode, page 44).

When the M9 is switched on, the LED at bottom right of the LCD will flash briefly, and after approximately one second, the camera will be ready to begin shooting.

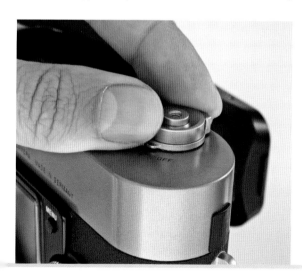

Note:
If left switched on, the M9 will power down after the period of time set in **Auto power off** in the Main menu (see page 88). Press the shutter-release button down lightly to "wake up" the camera.

SWITCHING THE CAMERA ON «
Use the main switch to turn the camera on.

› Formatting a memory card

Date	27.09.2010
Time	16:05
Acoustic signal	
Language	English
USB connection	Yes
Format SD card	Overwrite
Firmware	No

Most memory cards come preformatted; however, it is a good idea to format a new memory card or if it has been used in another camera previously. The M9 allows two types of formatting.

Quick formatting does not erase all the data on the memory card; only the file index is erased. This is a bit like ripping out the contents page of a book. Because the camera does not know that there are files on the card, it begins to overwrite them, building up a new file index as it does so. This means that if you accidentally format a card, it is still possible to rescue files held there using data recovery software. This must be done before anything else is written to the card.

When **Overwrite** is selected, everything on the card is erased and cannot be recovered. This includes any images that

have been protected. If you have anything important on your memory card, be sure to copy the files to a PC before formatting it using this method.

1) To format a memory card, press MENU.

2) Use either O or ▲ ▼ to highlight **Format SD card** and then press SET.

3) Highlight **Yes** for quick formatting or **Overwrite** to format the card fully, and then press SET once more. The greater the capacity of the memory card, the longer the formatting will take. Overwrite will always take longer than quick formatting.

Warning!

*If there is no memory card in your M9, the following warning message will be displayed on the LCD: **Attention No memory card***

Do not turn off your M9 during formatting, since this may damage your memory card.

***Overwrite** may take up to 60 minutes to format a large-capacity memory card, so recharge your battery fully before you start.*

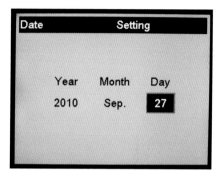

Color managem.	Adobe RGB
DNG setup	Compressed
Reset	
Sensor cleaning	
Date	27.09.2010
Time	Setting
Acoustic signal	Time format

Date	Setting	
Year	Month	Day
2010	Sep.	27

Making sure that the time and date are set correctly on your Leica M9 is important. When an image is written to the memory, the time and date when the image was captured are embedded into the file as metadata. The date and time are displayed in the detailed review screen in image playback (see page 58). Your PC operating system and image software, such as Lightroom, will also be able to use the time and date metadata to sort photos in chronological order.

Note:
Metadata is non-image data added to an image file. It includes date, time, and camera settings at the moment of image capture. Metadata such as keywords and copyright details can be added using post-production software (see page 182).

Setting Date and Time

1) Press MENU.

2) Use either ○ or ▲ ▼ to highlight **Date**. Press SET.

3) Highlight **Setting** and press SET once again.

4) The default time setting is displayed, with the first digit highlighted. Use ○ or ▲ ▼ to change the digits and ◄ ► to jump between the different digits.

5) Press SET to save the new time or MENU to exit without saving.

6) To set the time, repeat the process from step 2, this time highlighting **Time** in the main menu.

2

› Operating the shutter-release button

The shutter-release button has three distinct stages as you press down on it. If you briefly press the button down, to the point where there is some resistance, the camera metering and viewfinder display are activated. They will remain activated for a further 12 seconds. If you have self-timer set, the countdown to the shutter firing will begin.

If you keep the shutter-release button pressed down at this first resistance point, the metering and viewfinder display remain active until you release or push down the button completely. Exposure compensation can be set *(see page 50)* using the setting dial at this stage.

Pressing the shutter-release button down to the second resistance point locks the exposure setting in aperture priority

mode. The exposure will not alter unless you remove your finger from the button.

The final stage, when the shutter-release button is pressed down fully, fires the shutter and exposes the image.

> **Notes:**
> The shutter-release button is locked if the memory card or the internal image buffer is full. The button will unlock once space has been made on the memory card or once the image buffer clears.
>
> Pressing down on the shutter-release button cancels playback mode automatically.
>
> The way the shutter-release button operates can be altered on the Main menu option **Advance** *(see page 79).*

SHUTTER RELEASE «
The shutter-release button is a three-stage control.

› Cable release

The shutter-release button incorporates a thread that accepts a standard mechanical cable release. To fit the release, gently screw the end of the cable into the shutter-release button thread. Fire the shutter by pushing the plunger down on the cable release.

Most cable releases have a shutter-release button lock that allows you to hold open the shutter in Bulb mode *(see page 57)*. The lock is generally a small metal or plastic disk that rotates at the base of the cable release plunger. When the lock is screwed tight, the plunger will move freely back and forth. When the lock is unscrewed, so that it is at its loosest, the plunger will lock when you push it in. To release the plunger again, press down on the lock. To return to normal usage, rotate the lock back so that it feels tight.

To remove the cable release, gently unscrew it from the shutter-release button when the plunger is in the unlocked position.

A cable release is particularly useful when the M9 is mounted on a tripod and will help to avoid camera shake.

Warning!

When a cable release is attached to your M9, be sure not to knock it. Any sideways force where it is joined to your camera could at best break the cable release, or at worst, break the shutter-release button.

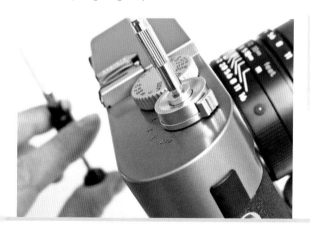

Note:
When a cable release is fitted, you will not be able to feel the second resistance point of the shutter-release button.

USING A CABLE «
RELEASE
A cable release will help prevent camera shake.

» USING THE VIEWFINDER

The viewfinder of the Leica M9 is used for deciding the composition of an image and to achieve focus, as well as displaying shooting information. The viewfinder is bright and clear, and is not blanked out during the shooting of an image in the way that a DSLR viewfinder would be. It is accurate with lenses of between 28 and 135mm. Wider-angle lenses require the use of a separate viewfinder that clips into the flash hotshoe *(see page 210)*.

Composition is aided by a bright line frame that has been corrected for parallax error. The bright line frame automatically adjusts when lenses with focal lengths of 28 (Elmarit from serial number 2411001), 35, 50, 75, and 135mm are fitted. With either a 28mm or 90mm lens fitted, the 28+90mm frames are both shown. With a 50mm or 75mm lens, both the 50+75mm frames are shown. Finally, when either a 35mm or 135mm lens is mounted, both the 35+135mm frames are displayed. The bright line frames can be changed at any point to display any of those three combinations.

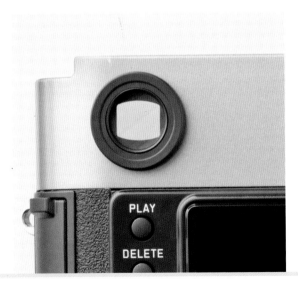

OPPOSITE TOP »
The outer bright lines correspond to the angle of view of a 35mm lens, the inner (surrounding the focus indicator rectangle) to a 135mm lens.

OPPOSITE CENTER »
The outer bright lines now correspond to the angle of view of a 50mm lens, the inner to a 75mm lens.

OPPOSITE BOTTOM »
The outer bright lines are now spaced to show the angle of view of a 28mm lens, the inner to a 95mm lens.

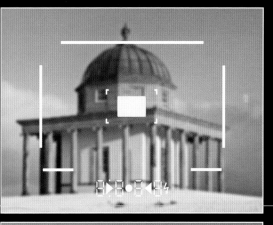

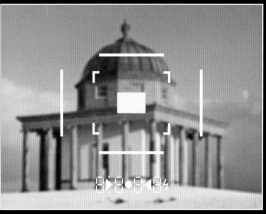

› Image field selector

As well as displaying bright lines for the lens currently mounted to the M9, the viewfinder can also display bright lines for other focal lengths. You can use this facility as a compositional aid to help you decide whether fitting another lens may be more appropriate for your subject. These alternative bright lines are selected by using the image field selector lever next to the lens.

The image field selector has three positions. Moving the lever outward, away from the lens, shows the field limits for 35 and 135mm lenses. With the lever centered and vertical, the field limits for 50 and 75mm lenses are displayed. Finally, with the lever at its closest point to the lens, the field limits for 28 and 90mm lenses are shown.

> **Note:**
> Parallax is the apparent shift in the position of an object when viewed from two different points in space. To see the effect, look at an object, open and close one eye and then the other. The viewfinder and the lens of the M9 are separated by a few centimeters, but even that tiny difference, without parallax correction, would be enough to make the viewfinder an unreliable guide to what the lens "sees."

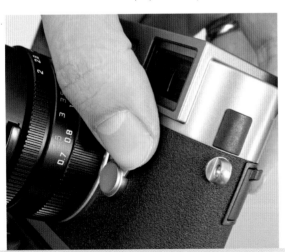

**IMAGE FIELD SELECTOR «
LEVER**
Moving this lever helps you visualize the required focal length of lens for a particular composition.

**DOMINANT »
FOREGROUND**
Accurate framing is vitally important when composing a shot in which the foreground is so dominant, such as this dramatic view of the Yorkshire Dales, UK.

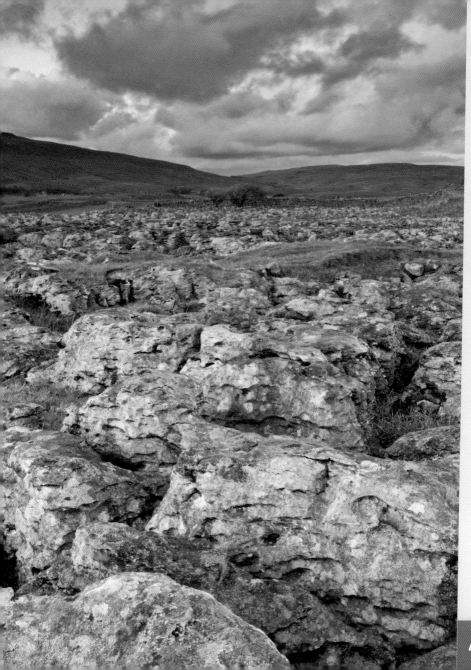

2 » FOCUSING

The Leica M9 relies totally on manual focus; there is no option to autofocus as on a DSLR. Looking down on the camera and lens combination, with the camera facing forward, turning the focus ring on the lens to the right moves the focus point closer to the camera, turning it to the left moves the focus point away. If your lens has a finger rest, use that in preference to the focus ring itself, since it will allow you to control focus more easily and smoothly.

The distance unit (shown in both feet and meters) that aligns with the white bar at the center of the depth of field scale is the distance at which the lens is focused. When the ∞ symbol is reached, the lens is focused on infinity and cannot be focused further. If you know the exact distance to your subject,

it is possible to focus using the lens distance scale only to achieve a very precise result.

Another method, for those who don't regularly carry around a tape measure, is to use the viewfinder to focus. The viewfinder can be used to focus lenses with a focal length between 16 and 135mm. With a lens fitted, look through the viewfinder; at the center is the focus indicator rectangle.

When your subject is out of focus, there will be a double image of the subject in the focus indicator rectangle. As the subject comes into focus, the double images will start to converge. Once they align, focus has been achieved. You can check the focus distance on the lens and confirm that the viewfinder is accurate, but generally this is not necessary.

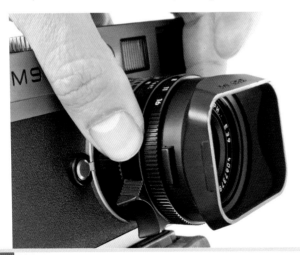

OPPOSITE TOP　　　　　》
The images in the focus indicator rectangle are not aligned, so focus for this subject has still not been set.

OPPOSITE BOTTOM　　　》
With the images in the focus indicator rectangle aligned, subject focus is now correct.

FOCUSING THE LENS　　《
Align the distance units with the distance marker on the lens.

» **DRIVE MODE**

The M9 has two frame advance modes, single and continuous, and an option to set a self-timer. These drive modes are set using the main switch *(see page 33).*

› Single (**S**)

Set to single advance, the M9 shoots one image for each single press of the shutter-release button. To shoot another image, the shutter-release button must be released and pressed down again.

› Continuous (**C**)

Set to continuous advance, the M9 can shoot up to a maximum of eight images in one burst at approximately two frames per second. However, these figures are dependent on the size of your memory card and the available space in the M9's image buffer. The last picture shot in the sequence will be the one that will be displayed on the LCD in Auto Review *(see page 88).*

› Self Timer (**Ⓝ**)

The self-timer can be set to 2 or 12 seconds In combination with a tripod and cable release, it is a useful method of preventing any risk of camera shake. To set the self-timer running, press the shutter-release button down to the first pressure point. The LED on the front of the M9 will flash for the first 10 seconds when timer delay is set to 12 seconds. At 2 seconds, the LED will stay lit until the shutter fires. To cancel self-timer during the countdown, press SET.

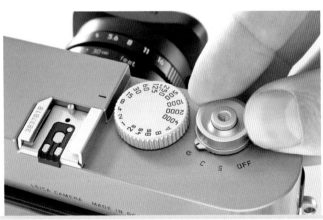

» METERING

To determine the correct exposure for a scene, the M9 uses a center-weighted, through-the-lens (TTL) exposure meter that measures light reflected from the shutter blades inside the camera. The metering range is EV 0 to 20 (or f/1.0 & 1.2 to f/32 & 1/1000).

In aperture priority mode, you manually select the aperture, and the M9 automatically adjusts the shutter speed based on this exposure reading. The selected shutter speed is shown in the LED display in the M9's viewfinder *(see page 19)*. In manual exposure mode, you set both the aperture and the shutter speed, and a series of indicators advises you on whether or not your settings are correct *(see page 56)*.

Switching the exposure meter on/off
With the M9 switched on, the exposure meter is activated by pressing the shutter-release button down to the first pressure point. Metering is not available in Bulb mode *(see page 57)*. The meter will remain active for 12 seconds once the shutter-release button has been released. When the viewfinder indicators are unlit, the M9 is in standby mode.

> **Notes:**
> A reflective meter (like that used in the M9) measures light that has been reflected back from the measured scene. This is different to an incident meter, which measures the light that falls onto a scene. Incident meters are generally more accurate, but once you understand the principals of how reflective meters work, their shortcomings can be accommodated (*see following pages*).
>
> EV or Exposure Value is a shorthand method of discussing common exposure situations. EV 0 is equivalent to the exposure required when shooting outdoors at night. EV 20 is the exposure needed when shooting a light source as bright as the sun.

CENTER-WEIGHTED «
Center-weighting is a name applied to metering that measures the entire scene, but is biased toward the center. Typically, approximately 60% of the metering reading is biased toward the center.

Exposure is a measurement of the total amount of light allowed to fall onto a piece of film or digital sensor to create a photographic image. The two methods by which light is controlled are by adjusting either (or both) the shutter speed and aperture.

The shutter speed is a unit of time measured in fractions of a second, from 1/4000, the fastest shutter speed selectable on the M9, to 8 seconds, the slowest. The M9 also has a bulb mode that allows you to lock open the shutter for up to a maximum of 240 seconds.

A typical range of shutter speeds is 1/1000, 1/500, 1/250, 1/125, and so on. The difference between each of these values is known as a "stop." Each of the stops represents either a halving (as the shutter speed increases) or a doubling (as it

decreases) of the amount of light let through to the sensor. For example, a shutter speed of 1/125 of a second lets through twice as much light as 1/250, but only half that of 1/60.

The aperture is an iris in the lens that can be opened or closed to allow more or less light through. The size of the aperture is measured in units called f/stops, represented by f/ and a suffix number. A typical range of f/stops on a Leica lens is f/2.8, f/4, f/5.6, f/8, and so on. The greater the suffix number, the smaller the aperture.

Note:
Shutter speed can be adjusted in ½-stop increments on the M9. So 1/750 would be half a stop's difference between 1/1000 and 1/500.

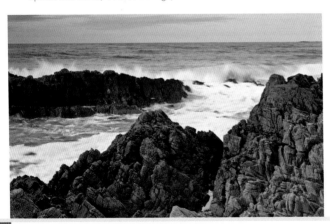

CREATIVE CHOICE «
For this photo, I deliberately chose a shutter speed of ¼ sec. to cause the movement of the waves to blur slightly. If I'd wanted a faster shutter speed, I would have needed to use a wider aperture and so risk losing overall sharpness due to lack of depth of field.

As with shutter speeds, each f/stop value on a lens represents either a doubling or halving of the amount of light let through. So, f/5.6 will allow in half as much light as f/4, but twice as much as f/8.

Different lenses have different maximum and minimum apertures. As a typical example, the Elmarit-M 28mm f/2.8 ASPH has a maximum aperture of f/2.8 (when the aperture is wide open) and a minimum aperture of f/22 (when the aperture is set to its smallest diameter).

Shutter speed/aperture relationship

When either the shutter speed or aperture is altered, the other must also change if you wish to maintain the same level of exposure. Shutter speed and aperture are said to have a reciprocal relationship. For example, if the shutter speed is increased by a stop (letting less light through to the sensor), the aperture must be made wider by a stop to compensate (to let more light through to the sensor).

Which combination of shutter speed and aperture you use is a creative decision. The aperture setting controls the depth of field of an image. A small aperture will maximize depth of field (and therefore overall image sharpness), but requires a relatively long shutter speed. Any movement in your image may be recorded as an indistinct blur. Conversely, a wide aperture will minimize depth of field, but will permit a fast shutter speed, enabling you "freeze" movement more effectively. *See pages 118–121* for more information about the creative use of aperture and shutter speed.

MERTOUN BRIDGE «
The exposure for this photo was 1/15 at f/11. The table below shows the different combinations of shutter speed and aperture to achieve the same exposure.

Shutter speed/Aperture
Shutter speed:
1/60 1/30 1/15 1/8

Aperture (f-stops):
f/5.6 f/8 f/11 f/16

The exposure meter in your M9 makes sense of a scene's light and shade by averaging out all the tones to a mid-gray. This works very well when a scene is conveniently "average." However, you will frequently encounter situations that aren't quite so obliging.

A scene chiefly composed of light tones, such as a snow scene, will often result in an underexposed image. This happens because the meter in the camera has darkened the light tones to pull them back to a mid-gray ideal. Snow scenes typically require 1.5 to 2 stops "overexposure" compared to the suggested value. With a dark-tone dominated scene, the exposure meter will tend to overexpose, again to bring the dominant tones back to mid-gray.

The histogram *(see page 52)* is an excellent tool that allows you to assess the exposure after capture. However, at the back of this book is a photographer's mid-gray card. The card is also known as an 18% gray card because it absorbs all but 18% of the light that falls on it. Using this card can help you determine the correct exposure no matter what the tonal range of the scene you wish to photograph.

SEA CAVE »
This shot required nearly two stops "underexposure" to retain the deep shadow and avoid burning out the sky beyond the cave.

› Using the 18% gray card

To use the card, first set the M9 to manual. Set either the aperture or shutter speed to the required value. Next, with the gray card in the same light as your scene, hold it in front of the lens so that it fills the frame—this is tricky with a rangefinder camera, so take a test shot and move the card if necessary. If you set the aperture before, adjust the shutter speed until the M9 confirms that exposure is correct. Do the opposite if you set the shutter speed previously. Remove the gray card and take the shot.

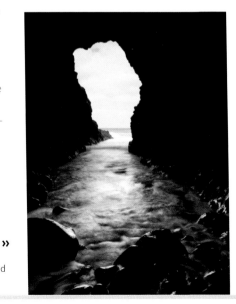

› Underexposure and overexposure

When a photograph is underexposed, the sensor has not received enough light to form a satisfactory image. This results in shadow detail being lost and lighter tones looking muddy. An overexposed image results in greater detail in the shadows, but lighter tones will look bleached out and highlights may be pure white and therefore "burnt-out."

However, in many ways exposure is a subjective and creative act, and there is no reason to use the "correct" exposure if you want to achieve a particular effect in the final image.

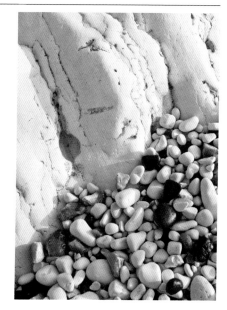

CHALK DEPOSITS　　　　　　　**»**
In contrast to the photo on the facing page, this shot required 1.5 stops of "overexposure" to compensate for the preponderance of light tones.

› Exposure compensation

Using manual exposure, it is easy to under- or overexpose an image as required. In aperture priority, if you want to alter the suggested exposure you need to use exposure compensation. The M9 allows you to alter exposure compensation in one of three ways.

AUTO ISO setup	1/60s / 800
Sharpening	Standard
Color saturation	Low
Contrast	Standard
Bracketing setup	SET menu only
Exp. comp. setup	Setting ring
Monitor brightness	Set. ring & rel. but.

Setting exposure compensation method 1

This method sets exposure compensation via the Parameters menu and therefore it will remain set until altered again. It is not available in Snapshot mode.

1) In shooting mode, press SET and highlight **Exposure comp**. Press SET once again.

2) Highlight the compensation value you require from the submenu.

3) Press SET again to choose the highlighted option and return to the main menu. Press MENU to return to the main menu without altering the original setting.

Setting exposure compensation method 2

This method allows you to adjust the exposure compensation using the setting dial. Once set, moving ⚙ in a clockwise direction increases exposure compensation; moving it counterclockwise decreases exposure compensation.

1) In shooting mode, Press MENU and highlight **Exp. comp. setup**. Press SET.

2) Highlight **Setting ring** and press SET once more.

Setting exposure compensation method 3

This method allows you adjust the exposure compensation using ⚙ while holding down the shutter-release button at its first pressure point. Once set, moving ⚙ in a clockwise direction increases exposure compensation, anti-clockwise decreases it. This will set the exposure compensation for the next picture you shoot.

1) In shooting mode Press MENU and highlight **Exp. comp. setup** and then press SET.

2) Highlight **Set. Ring & rel.** and press SET once more.

› Bracketing images

If you have a large-capacity memory card, another option is to bracket your images. This involves shooting three images of the same scene, one at the correct exposure, one overexposed, and the final one underexposed. This will quickly use up more memory card space and require longer to sort through your images in post-production, but it is a good safety net when in doubt. *See page 98* to set the M9 to bracket your shots.

» ISO

ISO is a well-established standard that measures the sensitivity of a piece of film or digital sensor to light. A low ISO figure means low sensitivity; a high ISO figure equates to high sensitivity. Low and high ISO are frequently referred to as slow and fast ISO respectively, and this is where the term ISO speed is derived. The speed to which your ISO is set will affect the combination of aperture and shutter speed necessary for a correct exposure.

A high ISO will allow you to use a faster shutter speed or smaller aperture than a low ISO. However, raising the ISO also increases the amount of noise in the final image. Noise is seen as random spots of color, and it reduces the amount of fine detail present in the image. Noise can be reduced using software such as Lightroom, but it is better to avoid it if possible. Using a high ISO therefore is something you should only consider if absolutely necessary.

The selectable ISO range on the M9 is 160 to 2500, with ISO 160 being the setting that will result in the least amount of noise in your images and ISO 2500 the greatest. It is possible to set the M9 to ISO 80 (PULL 80 on the ISO menu screen). However, this will result in images with reduced contrast and more likelihood that highlights will burn out. If you need to increase the shutter speed or use a wide aperture,

another possibility is to use an ND filter *(see page 215)*.

Setting ISO

1) In shooting mode, press and hold down ISO.

2) The available ISO settings will be shown arrayed as a grid on the LCD screen. Use ◀ ▲ ▼ ▶ or ⊙ to highlight the required ISO setting.

3) The ISO screen remains visible for two seconds after you release ISO and the highlighted ISO setting will be applied.

See page 80 for an explanation of AUTO ISO.

» HISTOGRAMS

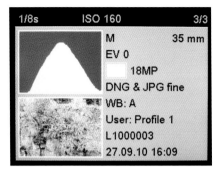

The LCD on the back of the Leica is not a precise instrument for judging the exposure of images. A more objective way to assess exposure is to use the histogram. The histogram allows you to precisely interpret the tonal range of your images and, if required, reshoot applying exposure compensation to adjust that range.

A histogram is a graph that records the complete range of tones in an image from pure black on the left edge to pure white on the right (with the mid-tones in the center). There is no ideal shape for a histogram. If possible, however, you should avoid "clipping" either edge. Once a histogram has been clipped, there will be no tonal information that can be adjusted in post-production.

For example, an area of shadow that is pure black (where the pixels have RGB values of 0,0,0) will have no texture. In Lightroom, you could adjust those pixels so

that they become dark gray, but you will not be able to pull out any more detail. The same is basically true of the highlights. However, Lightroom does have a method of "recovering" a certain amount of detail from blown highlights (see page 188).

The vertical axis of the histogram shows the number of pixels of a particular tone in the image. It does not matter if the histogram appears clipped at the top; this merely indicates that you have a large number of pixels of that tone in the image.

To check the histogram of an image, press INFO during image review. See page 85 for information on histogram setup.

Exposing to the right

Shooting RAW files gives you more latitude to correct exposure in post-production than when shooting JPEG.

Even when using RAW files, however, non-clipped shadow areas quickly become "noisy" if you try to lighten them after exposure. A common technique to avoid this is to "expose to the right." This means exposing the image so that the histogram is biased toward the right half, without clipping the highlights. This may result in a washed-out image on the LCD, but it will mean that more "information" is held in the shadows. Then, in post-processing, you would need to "pull back" the exposure using curves or levels to "normalize" the image and increase the tonal range so that the shadows look correct.

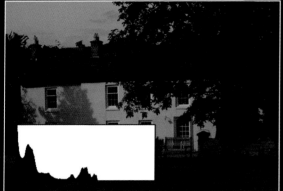

The first image *(top)* is underexposed. The shadow areas are dense and lacking in detail. The histogram, skewed to the left and clipped on the left edge, reflects this.

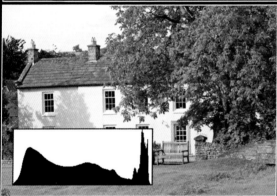

The second image *(center)* is a good exposure. There is detail in both the shadows and the highlights with no clipping at either edge.

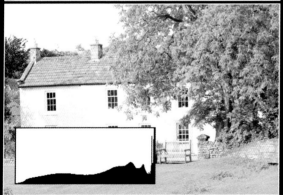

The final image *(bottom)* is woefully overexposed. The highlights are clipped, particularly in the sky, which looks very burnt out.

› The shutter speed dial

The shutter speed dial sets the M9 to aperture priority when in the (**A**) position marked in red. When a shutter speed is selected, it sets the camera to manual exposure mode. Also available is a (**B**) bulb mode for exposures of up to 240 seconds. The fastest flash sync speed of 1/180 sec. is marked by a red ϟ symbol.

The desired mode or shutter speed is selected by lining up the mode letter or shutter speed value with the black line etched on the camera body, to the left of the dial. The dial can be turned in both directions through 360°.

In manual exposure mode, the shutter speeds available range from 8 to 1/4000 sec. in ½-stop increments. Only full stop increments are shown on the dial itself;

½-stop values are selected by moving the dial halfway between two full stop values.

› Lens aperture ring

The various lenses available for the M-mount have different aperture ranges. The fastest lens in the Leica lineup, the Noctilux-M 50mm, has a maximum aperture of f/0.95! Most lenses have a minimum aperture of either f/16 or f/22. What all the lenses have in common is that aperture has to be set manually using the aperture ring.

As with the shutter speed dial, only full stop increments are shown on the ring; ½-stop values are selected by moving the ring halfway between two full stop values.

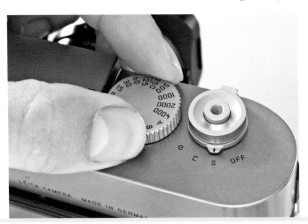

THE SHUTTER **«**
SPEED DIAL
Turn the dial to align the required mode or shutter speed with the black line etched on the camera body.

› Aperture priority (A)

When the shutter speed dial is turned to the (**A**) position, the M9 is set to aperture priority. The camera will now choose the appropriate shutter speed between 32 and 1/4000 sec., depending on the aperture and ISO setting you choose and the ambient lighting conditions.

The shutter speed chosen by the M9 is displayed in the viewfinder in ½-stop increments. Shutter speeds longer than 2 sec. will be counted down after the shutter has fired. When the required shutter speed is longer than 32 sec. or shorter than 1/4000 sec., this will exceed the shutter speed range of the M9. The M9 will fire the shutter at either 32 sec. or 1/4000 sec., but under- or overexposure will occur respectively. The shutter speed value will flash in the viewfinder as a warning.

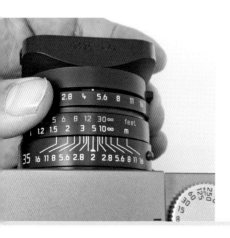

> **Note:**
> Metering memory lock is canceled if you lift your finger from the shutter-release button.
>
> Metering memory lock is not available if the shutter-release function is set to Soft *(see page 36)*.
>
> If the metering is incorrect apply exposure compensation *(see page 50)*.

Using metering memory lock

Because the meter is center-weighted, you may find that off-center subjects are incorrectly exposed. Using metering memory lock, it is possible to meter from part of a scene and then recompose to shoot a different part.

1) Point the camera at the part of the scene from which you wish to meter.

2) Press the shutter-release button to the second pressure point to activate the metering and save the reading. Keep the shutter-release button held at this point. A small red dot will be displayed above the digits in the viewfinder.

3) Move the camera and press the shutter-release button down fully to compose and capture your shot.

SETTING THE APERTURE **«**

In manual exposure mode, you control both the aperture and the shutter speed. This gives you enormous control over the final exposure of your images—they can be as under- or overexposed as you desire. This is also the drawback of manual exposure: with little automation to help, it can be all too easy to create exposures that are far from ideal.

Using manual exposure

1) Activate the camera metering by pressing the shutter-release button down to its first pressure point.

2) Look through the viewfinder. Use the table below to decipher the exposure information symbols at the bottom of the viewfinder.

3) If the exposure is not correct, alter either the shutter speed dial or aperture ring to correct for the difference until only ● is displayed in the viewfinder.

4) Press the shutter-release button down to take the shot.

Notes:
The direction of the arrows in the viewfinder indicates the direction you need to turn either the shutter speed dial or aperture ring. For example, the underexposure warning ▶ requires you to turn either the aperture ring or the shutter speed dial to the right to open the aperture or increase the length of the shutter speed respectively.

If the shutter speed is longer than 2 sec., the time is counted down and displayed in seconds once the shutter has been fired.

When light levels are low and the meter reading is outside the exposure meter's range, the left-hand triangular LED flashes.

Exposure indicator	Explanation
▶	Underexposure by more than one stop
▶●	Underexposure by ½ stop
●	Correct exposure
●◀	Overexposure by ½ stop
◀	Overexposure by more than one stop

» BULB (B) AND TIME (T) SETTINGS

As well as the shutter speeds marked on the dial, you can also opt to use (**B**) bulb mode. In bulb, the shutter will remain open as long as you hold down the shutter button. Using a cable release *(see page 37)* will allow you to lock open the shutter without requiring the use of a finger. The shutter can be held open for any period of time to a maximum of 240 seconds. Metering is disabled when the M9 is in bulb mode. Therefore it is up to you to decide how long the exposure should be.

When bulb is used in conjunction with self-timer, the (**T**) time function is made available. Pressing down on the shutter-release button once makes the self-timer open the shutter. The shutter remains open until you press down on the shutter-release button once more.

› Noise reduction

One of the problems with digital long exposures is that noise can gradually build up in the image because of electrical interference from the camera itself. Long exposures (from 1/30 sec. upward) therefore employ noise reduction to keep noise in the resulting images to a minimum.

This requires the M9 to shoot a second image at the same shutter speed, this time keeping the shutter closed. The noise present in the "black frame" image is then "subtracted" from the first image. Practically, this means that you have to expect a doubling of the time it takes to shoot a long exposure. The M9 will not be operational again until both exposures have been completed. During this time, you must not switch off the camera. The message **Noise reduction in progress** (and the time required) will be displayed on the LCD.

TRANQUILITY «
Using Bulb allowed me to expose this scene for 60 seconds, recording the waves as a tranquil blur.

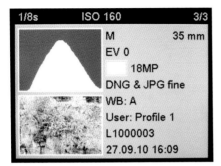

After an image has been written to the memory card, it will automatically be displayed on the LCD for a set period of time. The image can be shown full screen or at a reduced size with detailed shooting information, including a histogram. See **Auto review** *(page 88)* to set the options for image review after capture.

If **Auto review** is set to **Off**, you can still view the last image shot, and others on the memory card, by pressing PLAY on the rear of the M9. As with **Auto review**, images can be displayed full-screen or with detailed shooting information and histogram.

Press INFO and a detailed information screen showing shooting details and histogram will be displayed. The current image will be shown in the bottom left corner of the LCD.

By pressing ◀ ▶ you will be able to skip through and view the images on the memory card. Pressing ◀ will skip chronologically backward through your images; pressing ▶ will skip forward. Holding down either ◀ or ▶ for two seconds or more will increase the rate at which the images skip. Once you reach one end of the images on the card, the M9 will loop around and start again from the other.

› Magnify images

In image playback, turning ○ clockwise will enlarge the central section of the image. Using ◀ ▲ ▼ ▶ will allow you to navigate around the magnified image. The box in the bottom right corner of the LCD shows the proportion of the image that is being displayed and your current position within the image.

Notes:
When in playback mode, only those pictures in the currently active folder on the memory card will be displayed. *See page 86* for information about using different folders.

The histogram is not available when viewing more than one image onscreen in image index.

You can magnify up to 1:1, when one pixel in the image is shown as one pixel on the LCD. Turning ⭕ counterclockwise will zoom back out until the entire image is shown on the LCD once more.

When an image is magnified, it is still possible to jump between images on the memory. Hold down PLAY and use ◀ ▶. The next image you jump to will be displayed at the same magnification.

› Image index

In image playback, turning ⭕ counterclockwise will show an image index of four and, after another turn, nine image thumbnails. The current image is outlined in red. ◀ ▲ ▼ ▶ can be used to highlight any of the images in the index. Turn ⭕ clockwise and the highlighted image will be shown full screen.

› The PLAY button

Depending on what is displayed on the LCD, pressing PLAY has different effects. The table at the bottom of the page is a guide to what happens in these situations.

Note:
When nine thumbnails are displayed, turning ⭕ counterclockwise once more will highlight all the image thumbnails. You can now use ◀ ▲ ▼ ▶ to scroll more quickly through the images on your memory card, a block of nine at a time.

Warning!

*If the memory card does not contain images shot on the M9, **Attention No valid image to play** will be displayed on the LCD.*

Situation	Result after pressing PLAY
Full screen review	LCD is turned off
Magnified image/image index	Currently selected image is displayed full screen
INFO screen when image is magnified	Currently selected image is displayed in full with INFO
When DELETE or PROTECT has been pressed	Full-screen review of the last picture displayed

2 » DELETING IMAGES

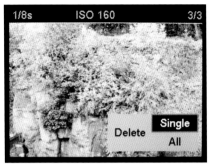

When the M9 is in playback mode, images can be deleted individually or you can delete every image on the memory card. Once an image has been deleted, it cannot be restored by the M9. If you delete an image accidentally, it is still possible to recover it using commercially available data-recovery software. However, you must do this before you create further images that may permanently overwrite the deleted file. You will not be able to delete images that have been protected until they have had protection removed.

Note:
Pressing DELETE rather than SET in the two operations described above right will cancel the DELETE function.

› Deleting individual images

In playback mode, navigate to the image you want to delete by pressing ◄ ►. Once the image is displayed on the LCD, press DELETE. Highlight **Single** and press SET. If the image has been protected, you will not be able to select **Single**.

› Deleting all images

In playback mode, press DELETE. Highlight **All** and press SET. Confirm that you wish to continue and press SET once more. All the images on the memory card will now be deleted except those that have been protected.

Once all the images on the card have been deleted, the message **Attention No valid image data to play** will be displayed on the LCD. If you have protected images on the card, the first protected image will be shown.

» PROTECTING IMAGES

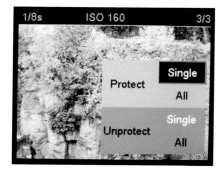
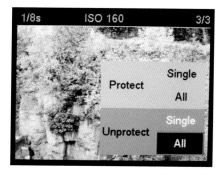

Protection can be applied to images that you want to prevent from being deleted accidentally. Unless you cancel protection, the only way to remove these images from the memory card is to format the card. Images can be protected individually or all images on the card can be protected.

› Protecting and unprotecting single images

In playback mode, navigate to the image you want to protect by pressing ◀ ▶ . When the image is displayed on the LCD, press SET. Highlight **Protect Single** and press SET once more. To unprotect an image, follow essentially the same procedure, but this time highlight **Unprotect Single** and press SET. When an image has been protected, ☐━ will be displayed on the LCD above that image during playback.

› Protecting and unprotecting all images

In playback mode, press SET. Highlight **Protect All** and press SET. All the images on the memory card will be protected (any images already set as protected will remain protected). To unprotect all images, follow the same procedure, but this time highlight **Unprotect All** and press SET once more. When the images have been protected, ☐━ will be displayed on the LCD above images during playback

Note:
If an option on the Protect menu is shown in white, it cannot be selected.

White balance	Auto
Compression	☀ Tungsten
Resolution	▥ Fluorescent 1
Exposure comp.	▥ Fluorescent 2
Exp. bracketing	☀ Daylight
Set user profile	⚡ Flash

Pure, neutral, white light is rare in nature. Most light has a tint, whether it is blue (resulting in a "cool" light) or red (resulting in a "warm" light). Our eyes are remarkably adept at adjusting for the color tint of light. It is only when the light source is particularly rich in color, such as at sunrise or sunset, that we really notice the difference. This variation in the color tint of light is known as a variation in the color temperature, measured using the Kelvin Scale (°K).

Black-body radiator

The Kelvin scale derives from a thought experiment. If a "black-body" radiator were heated up, it would quickly begin to glow. When the temperature reached 3200°K, the color of the glow would be a red-orange. By 10,000°K, the glow would be an intense blue-white. The colors, and the temperature at which those colors are emitted by the black-body radiator, are used as a scale to describe the color temperature of light. For example, a domestic tungsten bulb is very red-orange and has a color temperature of approximately 2800°K

White balance settings

AUTO White balance is determined automatically

 Tungsten (or incandescent) domestic lighting

 Warm-white (2700°K) fluorescent lighting

 Cool-white (4000°K) fluorescent lighting

 Daylight in normal sunny conditions

 Flash light

 Outdoors in cloudy conditions

 Outdoors in shadow conditions

Note:
A "black-body radiator" is an object that absorbs all light falling onto it and so is perfectly black—a theoretical impossibility, but a useful model for physicists and photographers.

› Compensating for tint

When something that is white, like a sheet of paper, is lit, the paper will be tinted by the predominant color of the light. A camera, being an objective recording device, will register that tinting and not record the paper as white. White balance is the process where this tinting is compensated for, restoring the whites to true white.

So, for example, anything white lit by tungsten lighting would be tinted red-orange. To correct this, the camera would add blue to the image to cancel out the color shift. When the M9 is set to Auto white balance, it will automatically adjust the white balance for you. However, this may not be accurate enough, so you can also choose from a range of presets for different lighting situations, select a Kelvin value directly, or create your own custom white balance.

Using a white balance preset
1) In shooting mode, press SET.

2) Use either **O** or **▲ ▼** to highlight **White balance** and press SET once more.

3) Use **O** or **▲ ▼** to move up and down the white balance options on the submenu. Press SET again to choose the highlighted option and return to the main menu. Press MENU to return to the main menu without altering the original setting.

4) Press lightly down on the shutter-release button to return to shooting mode.

Setting a Kelvin value

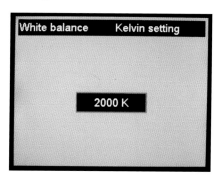

1) Follow steps 1 and 2 for using a preset.

2) Highlight **Kelvin setting** on the white balance submenu and press SET.

3) Use **O** or **▲ ▼** to move up and down the Kelvin values. The values range from 2000 to 5000°K in increments of 100°K; 5000 to 8000°K in increments of 200°K; and from 8000 to 13,100°K in increments of 300°K.

4) Press SET again to choose the highlighted option and return to the main menu. Press MENU to return to the main menu without altering the original setting.

Setting white balance manually

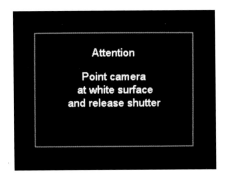

Attention

**Point camera
at white surface
and release shutter**

1) Follow steps 1 and 2 as set out on the previous page.

2) Highlight ☐ on the white balance submenu and press SET.

3) The message **Attention Point camera at white surface and release shutter** will be displayed on the LCD. Aim the M9 at a white surface (a sheet of paper or card is ideal) and press the shutter-release button to create a reference image. Try to fill the image with the white surface, but do not worry too much about focusing.

4) If the procedure has worked, the message **WB is set** will be displayed on the LCD, indicating that the custom white balance has been created. If the procedure fails, which will happen if the surface is not white, the message **WB not set** or **Bad Exposure** will be displayed. Use a different surface for the reference image and try again.

The custom white balance will be used until you change to another white balance setting. However, the custom white balance settings will be retained and can be recalled by following steps 1 to 3, then pressing SET instead of the shutter button.

Checking white balance

It is possible to check the white balance settings using an image histogram. Set the histogram to show the RGB information *(see page 85)*. After you've set the white balance using any of the methods described, shoot a picture of a neutrally colored sheet of card so that it fills the image. It doesn't need to be white, although if it is gray, it must be a pure gray without a color tint.

Review the image using Playback. The largest spike in the histogram will be the pixels that make up the card. If your white balance is correct, the red, green, and blue components of the histogram should be aligned. If it is incorrect, the dominant component color will be clearly visible in the histogram.

WHITE BALANCE ADJUSTMENTS »

If you are shooting RAW, white balance can be adjusted at the processing stage using Lightroom. The images opposite were all created from the same RAW file using different Kelvin settings. The image set to 5100°K most closely matches the light conditions at the time of exposure.

Top left, **7500°K**; *top right,* **5100°K**; *bottom left,* **3800°K**; *bottom right,* **2850°K**.

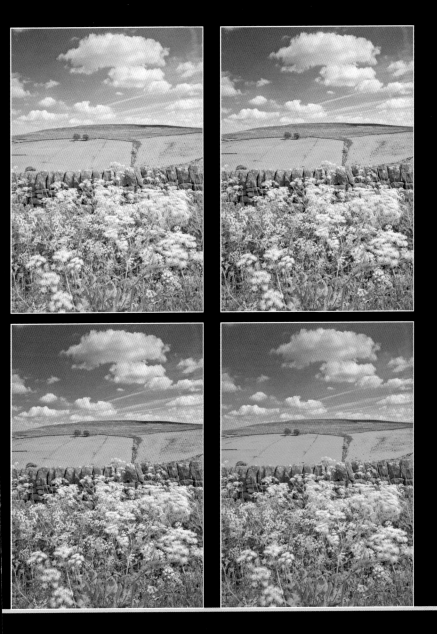

› Image Files

The image files stored on the memory card of your M9 conform to the naming standard supported by both PCs and Macs. The file name consists of a unique prefix number followed by an extension that denotes the image format. The files stored on the memory card can be viewed, deleted, protected, or transferred to another digital device. This is achieved either via a direct USB connection between the M9 and the device, or by removing the card from the camera and using a third-party card reader.

The M9 can create images in two different file formats: DNG RAW and JPEG. Both file formats have certain strengths and certain weaknesses. Which you choose will depend on your style of shooting and how quickly you need a "finished" photograph.

JPEG files

The JPEG file standard dates from 1992, when the Joint Photographic Experts Group created the format specifications. Since that time, JPEGs have become ubiquitous: they are the standard image type for web browsers, word processors, and of course digital cameras. JPEG files are identified by the extension .JPG (or occasionally .JPEG).

JPEG files are compressed, that is the digital information is "squeezed" to reduce the file size. This means that more image files in JPEG format can be fitted onto a hard drive than if those same files were saved in TIFF or RAW format.

However, this comes at a price, and the cost is that fine detail is discarded, reducing the overall quality of the image.

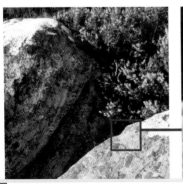

JPEG **«**
COMPRESSION
The close-up detail on the right shows the telltale artifacts of a JPEG that has had maximum compression applied.

The heavier the compression, the smaller the file size, but the greater the loss of fine detail. Shooting in JPEG format therefore is often a compromise between file size and image quality.

Once the detail has been lost, it is impossible to recover it. If your aim is to produce photographs for low-resolution applications, such as web pages, this is generally acceptable. However, if you plan to produce large prints or use your images for publication, consider opting for the RAW format instead.

When a JPEG is captured by the M9, the image options set on the Main and Parameters menus are "baked" into the file. Although it is possible to alter the look of your image in post-production, you will not be able to deviate too far without a reduction in image quality.

RAW files

RAW, in any form, is not compatible with anything other than RAW conversion software. This means that RAW files have to be processed and exported in a more "friendly" form before they can be used with other applications. Lightroom *(see Chapter 6)* will allow you to process your RAW files and export them as either JPEG, TIFF, or Photoshop PSD files.

RAW �
Processing a RAW file in Adobe Lightroom.

RAW files consist of all the data captured by the camera at the time of exposure. Because you have so much more information to work with, it is possible to create almost numberless variations of the same image. Indeed the idea of the Digital

> ### *Tip*
>
> *Sharpness and high contrast are the most difficult image qualities to tone down or remove in post-production. Set them to Off and Low respectively on the Main Menu if you think you'll want to alter your image extensively after capture.*

2

Negative deliberately harks back to the concept of the film darkroom and the creative act of interpreting a negative to make a print.

Lightroom does not physically alter your RAW files as you process them. Instead the changes you make are stored in a database and applied as a "recipe" of actions every time you return to your images. This means that you can interpret your images over and over again with no loss of quality in the original RAW file.

The Leica M9 allows you to save RAW compressed *(see page 90)*. This is achieved by removing some detail from the image, although not to the extent that a JPEG file does. However, whether saved compressed or uncompressed, the M9 RAW files will require more memory card space than an equivalent JPEG.

TIFF files

TIFF stands for Tagged Image File Format. It is widely used in publishing and design. The TIFF standard supports compression (both lossless and JPEG), 24-bit color, and Photoshop layer and channel information. Files have the extension .tif or .tiff (in either upper or lower case).

BEFORE AND AFTER ⌄

RAW files can often look disappointing when you first see them due to the lack of color saturation and contrast. It does take time to reach a point where the image looks satisfactory, so RAW files are far more time consuming than JPEGs.

There are two ways to transfer your files to your PC or Mac. The first, removing the memory card and using a USB card reader, involves the removal of the bottom cover. The second, slightly more convenient method is to connect your M9 directly to your PC via the supplied USB 2.0 cable.

The M9 can set the USB standard to either PTP (Picture Transfer Protocol) or Mass Storage. PTP is a relatively new standard for connecting cameras to PCs and is the preferred option. Some image editing software that can import files directly from a camera may not work without your M9 being set to PTP. The M9 can simply appear as another drive on your PC, so you can manually transfer the images across using Mass Storage.

Transferring files: Windows

1) Switch on the camera. Press MENU and change the **USB connection** setting to **PTP**.

2) Open the USB port cover on your M9 and plug in the USB cable. Connect the other end to a USB 2.0 port on your PC.

3) If this is the first time you have connected your M9, the PC will confirm that it has found new hardware. Double click on the message to remove it from the screen.

4) Now a window should open asking what you would like Windows to do next. Highlight **Copy pictures to a folder on my computer using Microsoft Camera and Scanner Wizard** and then click **Okay**.

5) Choose the images to copy by clicking on the checkbox in the top right corner of each image thumbnail. Click on **Next**.

6) Enter a name for your pictures. The image files will be retitled to this new name with a counter number (01, 02, etc.) added at the end. Choose a destination folder by clicking on **Browse**. Check **Delete pictures from my device after copying them** if you want Windows to remove the copied images from your memory card. Click **Next**.

7) Now the files should transfer. Turn off your M9 when transfer is complete and disconnect the USB cable.

> **Notes:**
> The M9 is compatible with USB 1.0 interfaces. However, data transfer will be considerably slower.
>
> PTP will transfer files from the active folder on your M9 only. To transfer files from other folders, use **Folder manag.** *(see page 86)* to navigate to other folders on the camera's memory card.

Transferring files: Mac OS X

1) Switch on the camera. Press MENU and change the **USB connection** setting to **PTP**.

2) Open the USB port cover on your M9 and plug in the USB cable. Connect the other end to a USB 2.0 port on your Mac.

3) Once a successful connection has been made, a confirmation will be displayed on the camera's LCD.

4) Open Finder on your Mac. Click on **Applications** in the Places category of the Finder window.

5) Double click on **Image Capture** to launch the Mac image transfer application.

6) When Image Capture is running, **M9 Digital Camera** will appear in the application title bar.

7) Select a folder to which to copy the images by clicking on the **Download to** drop-down menu: select **Other** and navigate to the desired folder.

8) Click on **Options** to select any action that you want the Mac to take during the copying process. Click on **Download All** to copy all the images on the camera's memory card or **Download Some** to select a range.

9) Quit Image Capture once copying is complete, turn off your M9 and disconnect it.

Note:
If you download and install Lightroom for either PC or Mac, the software will automate the copying process for you. *See page 177 for more information about importing images into Lightroom.*

DUNSTANBURGH CASTLE »
Getting down low is almost a requirement of landscape photography. Doing this will allow you to fill the foreground and visually lead the eye through the image.

2 » MENU SUMMARY

Note: Items grayed out are not available when the M9 is set to Snapshot

Main Menu Item	Options
Lens Detection	Off; Auto; Manual (lens selection from list)
Save user profile	Save as 1; Save as 2; Save as 3; Save as 4
Advance	Standard; Soft; Discreet; Discr. & Soft
Self timer	Off; 2 sec.; 12 sec.
Auto ISO setup	Slowest speed (Lens dependent; 1/125 sec.; 1/60 sec.; 1/30 sec.; 1/15 sec.; 1/8 sec.); Max ISO (ISO 80–2500)
Sharpening	Off; Low; Standard; Medium High; High
Color Saturation	Low; Medium Low; Standard; Medium High; High; Black & White; Vintage B & W
Contrast	Low; Medium Low; Standard; Medium High; High
Bracketing setup	No. of exposures (3; 5; 7) Sequence (0 / + / – ; – / 0 / +) EV increments (0.5 EV; 1 EV; 1.5 EV; 2 EV)
Exp. Comp. setup	SET menu only; Setting ring; Sett. ring & rel. but.
Monitor brightness	Low; Medium Low; Standard; Medium High; High
Histogram	Standard; RGB; Clipping setup (Off; Overexposure only; Over/Underexposure)
Folder manag.	Select folder (folders on memory card); Create new (text input); Reset folder no.
Auto review	Duration (Off; 1 sec.; 3 sec.; 5 sec.; Permanent; Rel. button pressed) Histogram (On; Off)

Main Menu Item	Options
Auto power off	1 min.; 2 min.; 5 min.; 10 min.; Off
Flash sync	1st curtain; 2nd curtain
Auto Slow Sync	Lens dependent; Off (1/180 sec.); Down to 1/30 sec.; Down to 1/8 sec.; Down to 32 sec.
Color manag.	sRGB; Adobe RGB
DNG setup	Uncompressed; Compressed
Reset	No; Yes
Sensor cleaning	No; Yes
Date	Setting (Year; Month; Day) Sequence (Day . Month . Year; Month / Day / Year; Year / Month / Day)
Time	Setting (Hour; Minutes) Time format (12 hours; 24 hours)
Acoustic signal	Volume (Off; Low; High) Keyclick (Off; On) SD Card full (Off; On)
Language	English; German; French; Italian; Spanish; Japanese; Trad. Chinese; Russian
USB connection	Mass Storage; PTP
Format SD card	Yes; Overwrite; No
Firmware	Currently installed firmware version

Parameters Menu Item	Options
White balance	Auto; Tungsten; Fluorescent 1; Fluorescent 2; Daylight; Flash; Cloudy; Shadow; Manual; Kelvin setting
Compression	DNG; JPG fine; JPG basic; DNG+JPG fine; DNG+JPG basic
Resolution	1 MP (1280 x 846); 2 MP (1728 x 1152); 4.5 MP (2592 x 1728); 10 MP (3840 x 2592); 18 MP (5212 x 3472)
Exposure Comp.	-3.0 to +3.0 EV; 1/3 EV steps
Exp. Bracketing	Off; On
Set user profile	Snapshot profile; Profile 1; Profile 2; Profile 3; Profile 4

Snapshot—Main	Settings

Note: When the M9 is set to Snapshot, the grayed out items will not be displayed on the menu, but will be fixed at the settings shown

Lens detection	Auto
Advance	Standard
Self-timer	12 sec.
AUTO ISO setup	AUTO ISO/Lens dependent/ISO 800 (max)
Sharpening	Standard
Color saturation	Available
Contrast	Standard
Monitor brightness	Standard
Histogram	Standard

Snapshot—Main	Settings
Auto review	3 sec. (Histogram off)
Auto power off	2 min.
Flash sync	1st curtain
Auto Slow Sync	Lens dependent
Color manag.	sRGB
Date	Available
Time	Available
Acoustic signal	Off
Language	Available
USB connection	Mass storage
Format	Available

Snapshot—Parameters	Settings
White balance	Auto
Compression	JPG fine
Resolution	18 MP
User profile	Snapshot mode

Lens detection	Auto
Save user profile	
Advance	Standard
Self timer	12 s
AUTO ISO setup	1/60s / 800
Sharpening	Standard
Color saturation	Standard

The M9 Main menu allows you to control the non-mechanical functions of your camera, from setting the ISO to LCD brightness. When the M9 is set to Snapshot (see page 99), most menu items will be fixed and you will not be able to alter the settings. In Playback, Aperture Priority, and Manual Exposure modes, a separate Image Parameters menu screen is available that allows you to alter specific image settings without needing to scroll through the Main menu (see page 96).

Using and altering settings on the Main menu

1) Press MENU.

2) Use either ○ or ▲ ▼ to move up and down the menu screen and highlight the various settings.

3) Press SET to alter the highlighted setting.

4) Use ○ or ▲ ▼ to move up and down the options on the submenu and highlight the various choices for that setting. Press SET again to choose the highlighted option and return to the Main menu. Press MENU to return to the Main menu without making any changes to the original setting.

5) Press SET to alter the highlighted setting.

6) Press lightly down on the shutter-release button to go directly to shooting mode. Press PLAY to go directly to image review. Press MENU to exit from the menu system.

› Lens detection

Lens detection	Off
Save user profile	Auto
Advance	Manual
Self timer	12 s
AUTO ISO setup	1/60s / 800
Sharpening	Standard
Color saturation	Standard

Lens detection	Manual
16-18-21 ASPH. f/4 @ 16mm 11626	
16-18-21 ASPH. f/4 @ 18mm 11626	
16-18-21 ASPH. f/4 @ 21mm 11626	
21 f/2.8 11134	
21 f/2.8 ASPH. 11135/11897	
24 f/2.8 ASPH. 11878/11898	

The M9 has a 6-bit optical sensor on the lens mount. When mounting a compatible lens (fitted with a simple data barcode), the sensor will read the barcode and determine the lens type. This information is used in a variety of ways, from correcting the effects of light fall-off (often a problem with wide-angle lenses at maximum aperture) to ensuring the EXIF data in the image metadata is set correctly.

When a lens without the data barcode is mounted to your M9, Lens detection should be set to **Off** or **Manual**. When **Manual** is selected, a list of lenses is displayed. If your lens is included in this, highlight it and then press SET to return to the Main menu.

Notes:
All Leica lenses designed or updated since July 2006 will have a barcode and cannot be selected manually from the list.

The LEICA TRI-ELMAR-M 16-18-21mm ASPH. f/4 has three focal length settings and a separate entry on the lens list for each focal length. You will need to change the setting on the Manual submenu each time you alter the focal length of the lens.

Match Technical Services *(http://matchtechnical.com)* have created a lens coding kit that permits you to add a lens barcode to earlier or non-Leica lenses.

Lens detection	Auto
Save user profile	Save as 1
Advance	Save as 2
Self timer	Save as 3
AUTO ISO setup	Save as 4
Sharpening	Standard
Color saturation	Standard

The M9 allows you to save up to four different "profiles" with different camera settings from the Main and Parameter menus registered to each profile. This allows you to quickly set your camera to a particular mode for different shooting situations. Each profile can be assigned a name of up to 10 characters, using A to Z, a to z, or 0 to 9. The Snapshot mode essentially is another profile with settings defined by Leica (see page 99).

Creating a profile

1) Alter the options on the Main and Parameter menus to your desired settings.

2) If you are not already there, go to the Main menu and highlight **Save user profile**. Press SET and then highlight one of the four profiles. Press SET again.

3) Use O or ▲ ▼ to change characters. Use ◄ ► to jump between the different characters.

4) Press SET once more to save the profile.

Selecting a profile

1) Press SET to view the Parameters menu (see page 96).

2) Highlight **User profile**, press SET, and then highlight the required profile. Press SET once more to start using that profile.

Resetting all profiles

1) On the Main menu, highlight Reset and then press the SET button.

2) Highlight **Yes** and press SET. The camera will then be reset to the factory default settings.

› Advance

Lens detection	Auto
Save user profile	
Advance	**Standard**
Self timer	Soft
AUTO ISO setup	Discreet
Sharpening	Discr. & Soft
Color saturation	Standard

The M9 is far from being a noisy or awkward camera to use, but in certain situations you may want to refine the handling or minimize the shutter cocking noise as much as possible. There are four options available on the Advance menu: Standard, Soft, Discreet, and Discreet and Soft combined.

Standard
The shutter-release button and cocking mechanism functions as normal.

Soft
The shutter-release button is fired at the second pressure point without the resistance of the intermediate stage.

Discreet
The shutter mechanism is only cocked once you take your finger off the shutter-release button. Keeping your finger on the shutter-release button, you could move the camera from a location where the cocking noise would be unwelcome. There is no time limit to how long the shutter is kept uncocked—the only limit is the strength in your finger!

Discreet and soft
A combination of the two options above.

> *Note:*
> Discreet only works when the drive mode is set to Single. Soft works in both Single and Continuous modes.

› Self-timer

› AUTO ISO setup

Lens detection	Auto
Save user profile	
Advance	Standard
Self timer	Off
AUTO ISO setup	2 s
Sharpening	**12 s**
Color saturation	Standard

Lens detection	Auto
Save user profile	
Advance	Standard
Self timer	12 s
AUTO ISO setup	**Slowest speed**
Sharpening	Max ISO
Color saturation	Standard

Keeping your camera steady is an important part of achieving the sharpest possible images. Using your M9 on a tripod and setting the self-timer to fire the shutter is a good way to achieve this. Any movement transmitted to the camera when pressing down the shutter button is negated by the delay in the shutter firing.

When AUTO ISO is selected on the ISO setup screen *(see page 51)*, the M9 will automatically increase the ISO to allow faster shutter speeds to be used if the light level of a scene drops. This will help to avoid camera shake if you are handholding your M9. If you intend to mount the camera on a tripod, set ISO to 160 for maximum quality. You can set when the change occurs by using the options on the **AUTO ISO setup** submenu.

Notes:
The longer the lens, the faster the shutter speed needs to be to avoid the danger of camera shake when a camera is handheld. The general rule is that the shutter speed needs to roughly match the focal length of the lens. If you were to use a 135mm lens, you would need to use a

shutter speed of 1/150, whereas it may be possible to handhold an 18mm lens as low as 1/25. Different people have different capabilities, and the only way of discovering yours is to experiment.

Lens dependent will only work with lenses that are coded.

This option allows you to set either the longest shutter speed the camera needs to reach before ISO alters, or whether the focal length of the lens has an influence on when ISO is changed.

Setting the shutter speed

1) Highlight **AUTO ISO setup**. Press SET.

2) Highlight **Slowest speed**. Press SET.

3) Highlight **Lens dependent** if you want the M9 to change ISO once the shutter speed drops to a point where camera shake may become a problem with the lens fitted to the camera.

4) Alternatively, highlight the slowest shutter speed you feel you can comfortably shoot at when handholding and still avoid camera shake.

5) Press SET to return to the AUTO ISO setup submenu.

This option allows you to set the maximum ISO the camera will choose when AUTO ISO is selected. Remember that the higher the ISO setting, the more noise will degrade image quality. However, noise in an image is preferable to lack of sharpness due to camera shake. Noise can be reduced, but camera shake cannot be corrected in post-processing.

1) Highlight **AUTO ISO setup**. Press SET.

2) Highlight **MAX ISO**. Press SET.

3) Use O or ▲ ▼ to highlight the required maximum ISO value.

4) Press SET to return to the AUTO ISO setup submenu.

The following three options apply only when you are shooting JPEG images. They will affect the overall look of your image in a way that may be difficult to undo if you intend to apply any post-processing. However, careful use of these three settings will allow you to shoot images that are ready for immediate use, either as finished images to be printed or for uploading to social media web pages.

› Sharpening

Lens detection	Auto
Save user profile	
Advance	Off
Self timer	Low
AUTO ISO setup	**Standard**
Sharpening	Medium high
Color saturation	High

› Avoiding camera shake

Camera shake is caused when the camera moves during a long exposure. Generally, shooting on a tripod is the best way to avoid its effects, but there are techniques to minimize the risks when handholding:

CAMERA SHAKE
This image suffers badly from camera shake; the shutter speed of 1/10 sec. was too long to successfully handhold the camera.

- Stand as relaxed as possible, with your feet approximately shoulder-width apart.

- Tuck your elbows lightly against your body.

- With your right hand, hold the camera firmly with your index finger resting lightly on the shutter-release button. Use your left hand to support the base of the camera and the lens.

- Breathe in and out. Before you breathe in again, gently push the shutter-release button down smoothly to take the shot.

- If you're shooting from a kneeling position, steady your upper body by resting your elbow on one knee.

This option allows you to set the level of sharpening that is applied to your images. If you intend to submit your images to stock libraries, set the sharpening to **Off**. Different methods of reproducing images require different levels of sharpening. Most libraries insist that no sharpening be applied to images, to allow their clients to choose their own sharpening levels. *See page 124* for more about the effects of sharpening.

› Color saturation

Save user profile	Low
Advance	Medium low
Self timer	**Standard**
AUTO ISO setup	Medium high
Sharpening	High
Color saturation	Black & White
Contrast	Vintage B & W

This option lets you set the level in intensity of the colors in your images. **Low** color saturation will result in a muted image; **High** saturation increases the vividness. There is also the option to shoot **Black & White** images that are neutral in tone, or **Vintage B&W** that have a sepia tint.

› Contrast

Advance	Standard
Self timer	12 s
AUTO ISO setup	Low
Sharpening	Medium low
Color saturation	**Standard**
Contrast	Medium high
Bracketing setup	High

Contrast lets you set how the tonal range of the image is controlled. **Low** contrast will result in flat-looking images, but with more detail in both the highlights and shadows. **High** contrast will create a punchier image with less detail in the highlights and shadows. If you intend to adjust your images in post-production, it is easier to add contrast to an image than remove it, so set **Contrast** to **Low** or **Medium low**.

› Bracketing setup

Self timer	12 s
AUTO ISO setup	1/60s / 800
Sharpening	Standard
Color saturation	Low
Contrast	**No. of exposures**
Bracketing setup	Sequence
Exp. comp. setup	EV increments

Bracketing is the shooting of more than one image using a different exposure for each image to ensure that you have one image that is correctly exposed.
Bracketing setup has several options.

The first, **No. of exposures**, allows you to select the number of images shot between 3, 5, and 7. Typically, bracketing is done with three images (one at the "correct" exposure, one "underexposed," and one "overexposed"). However, if you intend to use high dynamic range (HDR) to create an image with a wide tonal range, the more exposures you have, the greater the potential tonal range of your HDR merge.

The second option lets you choose the sequence of the bracketing. This is set depending on personal preference. When you are used to the bracketing order, leave it set that way to avoid confusion later.

EV increments lets you set the range of the bracketing in EV units (an EV unit is equivalent to a stop: *see page 45*). If there is a big difference in contrast between the shadows and the highlights, use a wide bracketing range.

Notes:
Bracketing only works in Aperture Priority mode.

When using AUTO ISO, the ISO selected for the first shot in the sequence is used for all the shots.

If bracketing requires a shutter speed that exceeds those available, the closest speed will be used instead.

With seven exposures, only 0.5 and 1 EV are available on **EV increments**.

› Exp. Comp. setup

AUTO ISO setup	1/60s / 800
Sharpening	Standard
Color saturation	Low
Contrast	Standard
Bracketing setup	**SET menu only**
Exp. comp. setup	Setting ring
Monitor brightness	Set. ring & rel. but.

Exposure compensation when shooting in aperture priority can be set in one of three ways *(see page 50)*. This menu option allows you to set the method that is most appropriate for your personal shooting style.

› Monitor brightness

Sharpening	Standard
Color saturation	Low
Contrast	Low
Bracketing setup	Medium low
Exp. comp. setup	Standard
Monitor brightness	Medium high
Histogram	High

The brightness of the LCD can be set using this option. The brightness should be adjusted according to the ambient lighting conditions so that you can see the screen properly. However, it's important to note that even if you have the brightness set correctly, it is not a good idea to rely on the LCD for exposure appraisal. The histogram *(see page 52 and right)* is a far more objective and accurate means of achieving this.

› Histogram

Color saturation	Low
Contrast	Standard
Bracketing setup	3 / -/0/+ / 0.5 EV
Exp. comp. setup	Set. ring & rel. but.
Monitor brightness	Standard
Histogram	RGB
Folder managem.	Clipping setup

The M9 can display a histogram that shows you the range of tones in a captured image. The default is Standard, in which a luminance or overall brightness histogram is displayed.

You can also choose to display an RGB histogram. This is where the red, green, and blue components of your image are shown on the histogram. This is a useful way to check that white balance is set correctly *(see page 52)* or that particular colors in your image aren't over saturated.

Clipping setup allows you to choose whether a warning is displayed when the histogram has clipped *(see page 53)*. In the image display, any area that is shown in red is a highlight area that is overexposed; any area that is blue is underexposed.

Contrast	Standard
Bracketing setup	3 / -/0/+ / 0.5 EV
Exp. comp. setup	Set. ring & rel. but.
Monitor brightness	Standard
Histogram	**Select folder**
Folder managem.	Create new
Auto review	Reset folder no.

When an image is created and saved to your memory card, it is saved into a Leica folder on the card (you could potentially use the same card in a different camera—that camera would then create another folder for its own images). You can create different Leica folders so your images do not necessarily need to be grouped into one big "pot." The Leica folders use the convention of three numbers and then five letters or numbers. Set to factory default, the first folder is named 100LEICA, the second would be 101LEICA, and so on up to folder 999.

Folder managem. allows you to select and use different folders, create new folders on the memory card, change the five letters used to name folders when they are created, and reset the folder name counter.

Selecting folders

1) Highlight **Folder managem.** and press SET.

2) Highlight **Select folder** on the submenu and press SET once more. A list of the available folders will be displayed on the LCD. The greater the number of folders, the longer it will take to show the full list. The message **Folders are being read Please wait** will be displayed if this process is taking time.

3) Highlight the required folder and then press SET.

Creating and naming folders

Although LEICA is the default five-letter suffix used when a folder is created, you can change this to any combination of five letters that is relevant to you.

1) Highlight **Folder managem.** and then press SET.

2) Highlight **Create new folder** on the submenu and press SET. The word LEICA will appear as the default folder name, with a cursor over the first letter.

3) Use ⭘ or ▲ ▼ to change the highlighted letter. Use ◀ ▶ to jump between the different letters. You can alter the folder name using A to Z, a to z, or 0 to 9.

4) Press SET to exit from the folder creation screen and create the new folder, or MENU to exit without creating the folder.

> **Note:**
> When using the PTP setting to transfer images to your PC *(see pages 69–70)*, only those images from the active folder on your M9 will be transferred. Use **Select folder** to navigate to other folders on the M9's memory card and transfer each folder's contents in turn.

Resetting folder numbers

This option only applies when you insert a memory card that is freshly formatted or does not have Leica image folders created previously.

1) Highlight **Folder managem.** and then press SET.

2) Highlight **Reset folder no.** on the submenu and press SET once more. The internal counter of folders on the Leica will be reset, and the next folder created will be 100 (unless there are folders on the card that conform to Leica's naming convention, in which case the number of the next folder created will follow on from these folders).

› Auto review

Bracketing setup	3 / -/0/+ / 0.5 EV
Exp. comp. setup	Set. ring & rel. but.
Monitor brightness	Standard
Histogram	RGB
Folder managem.	LEICA
Auto review	**Duration**
Auto power off	Histogram

When you create an image with your M9, once it has been written to the memory card, it will be displayed on the LCD. This option allows you to choose how long the image will remain on the LCD and whether or not a histogram is also displayed.

› Auto power off

Exp. comp. setup	Set. ring & rel. but.
Monitor brightness	Standard
Histogram	1 min.
Folder managem.	2 min.
Auto review	5 min.
Auto power off	10 min.
Flash sync	Off

To conserve battery power, the Leica will automatically power down if it has not been used for a time. This is equivalent to turning the camera off using the main switch, so little or no power will be drawn from the main battery. Auto power off lets you set the duration of time before this powering down process and whether the function activates at all.

› Flash sync

Monitor brightness	Standard
Histogram	RGB
Folder managem.	LEICA
Auto review	Permanent
Auto power off	2 min.
Flash sync	**1st curtain**
Auto slow sync	2nd curtain

The M9 allows you to set your flashgun to fire either when the 1st curtain rises (1st curtain synchronization) or when the 2nd curtain follows (2nd curtain synchronization). This generally does not make a difference to your flash photography unless there is movement across the image frame during exposure. *See page 164* for more details.

Note:
Pressing the shutter-release button down lightly will restart the M9.

› Auto slow sync

Histogram	RGB
Folder managem.	LEICA
Auto review	Lens dependent
Auto power off	Off (1/180s)
Flash sync	Down to 1/30s
Auto slow sync	Down to 1/8s
Color managem.	Down to 32s

Flash exposure is not affected by the shutter speed you set. However, the shutter speed will affect the exposure for anything in the scene that is not lit by flash light. The settings in Auto slow sync allow you to set the behavior of the shutter speed when a flashgun is attached. *See page 166* for more details.

› Color managem.

Folder managem.	LEICA
Auto review	Permanent
Auto power off	2 min.
Flash sync	1st curtain
Auto slow sync	Down to 1/8s
Color managem.	sRGB
DNG setup	Adobe RGB

This option allows you to specify the color space in which your images are saved. The color space of a digital device refers to the range of colors it can either record or display/print. The M9 can record images using sRGB or Adobe RGB color space.

The sRGB color space is used primarily as a color space for monitors, printers, and Internet applications. It has a smaller color range than Adobe RGB, but is the color space you would use if you want your images to be "print ready" with little or no post-processing applied.

Because the Adobe RGB color space is larger, it has more "headroom" for post-processing. This is the color space you should use if you intend to work on your images extensively after capture. However, it is recommended that you work in a fully calibrated system, including monitor and printer, to get the best out of Adobe RGB.

FUNCTIONS » MAIN MENU OPTIONS

THE EXPANDED GUIDE
89

› DNG setup

Auto review	Permanent
Auto power off	2 min.
Flash sync	1st curtain
Auto slow sync	Down to 1/8s
Color managem.	Adobe RGB
DNG setup	Uncompressed
Reset	Compressed

The M9 DNG RAW files can be saved either compressed or uncompressed. If saved compressed, a small amount of image quality will be lost, but the files will take up less space on the memory card and be written to the card more quickly.

› Reset

Reset	
Set camera to basic settings?	
	No Yes

The Leica M9 can be reset to its original factory settings. This will reset all of the settings on the Main and Parameter menus that can and have been altered by you. This includes any profiles saved using **Save user profile** (*See page 78*).

› Sensor cleaning

Sensor cleaning	
Do you want to inspect the sensor?	
	No Yes

Dust is the bane of a photographer's life. No matter how careful you are, dust will invariably build up on the sensor of your M9. Unlike some modern DSLRs, the Leica M9 does not have an automatic dust removal system. Therefore, dust has to be removed manually by selecting this option—which holds open the shutter, exposing the sensor—and using a low-pressure air blower or other cleaning tool. *See page 233* for more information about cleaning the sensor.

› Date

Use this option to set the correct date *(see page 35)*. You can also choose how the date format is displayed by selecting **Sequence**. The choices are **Day . Month . Year,** **Month / Day / Year**, or **Year / Month / Day**. Whatever you select will not affect how this information is stored in the image metadata; it is purely for personal preference when the date is displayed on the review screen in Playback mode.

› Time

Use this option to set the correct time *(see page 35)*. You can also choose how the time format is displayed by selecting **Time format**. The choices are **12 hours** or **24 hours**. Like **Date**, this is purely a personal preference for the way the time is displayed on the detailed review screen in Playback mode.

SPOTS IN THE SKY »
Dust spots are particularly noticeable in areas of even tone such as blue sky.

› Acoustic signal

DNG setup	Compressed
Reset	
Sensor cleaning	
Date	27.09.2010
Time	Volume
Acoustic signal	Keyclick
Language	SD card full

The M9 can make various sounds to confirm when certain functions and warning messages are activated. These sounds have two levels of volume. By default, these audio signals are turned off.

Setting the audio signals

Acoustic signal	SD card full
	Off
	On

1) Highlight **Acoustic signal** and press SET.

2) To alter **Volume**, highlight the option and press SET.

3) On the **Volume** submenu, highlight **Off** (no sound), **Low**, or **High**. Press SET to choose the option highlighted and return to **Acoustic signal**.

4) To activate the sound played whenever a button is pressed, highlight **Keyclick** and press SET. On the **Keyclick** submenu, highlight either **Off** or **On** according to your preference. Then press SET to choose the highlighted option and return to **Acoustic signal**.

5) To activate the warning sound played when your memory card is full, highlight **SD card full** and press SET. On the **SD card full** submenu, highlight either **Off** or **On** according to your preference. Press SET to choose the highlighted option and return to **Acoustic signal**.

› Format SD card

Date	27.09.2010
Time	16:05
Acoustic signal	
Language	English
USB connection	Yes
Format SD card	Overwrite
Firmware	No

It is recommended that you format a new memory card, or one that has been used in another camera. *See page 34* for instructions.

› USB connection

Sensor cleaning	
Date	27.09.2010
Time	16:05
Acoustic signal	
Language	English
USB connection	Mass storage
Format SD card	PTP

Removing the memory card from your M9 whenever you wish to transfer images to your PC can be a time-consuming affair. To make this process easier, you have the option of connecting the camera to your PC directly via a USB cable. This option sets the connection standard used by your PC. *See page 69* for more information.

› Language

Reset	English
Sensor cleaning	German
Date	French
Time	Italian
Acoustic signal	Spanish
Language	Japanese
USB connection	Trad. Chinese

The M9 can display information on the menu screens in the following languages: English; German; French; Italian; Spanish; Japanese; Trad. Chinese; Russian. Be careful not to set your M9 to a non-Roman language unless you speak that language. You may find locating and resetting the **Language** to something more familiar almost impossible.

› Firmware

Date	27.09.2010
Time	16:05
Acoustic signal	
Language	English
USB connection	PTP
Format SD card	
Firmware	1.138

The Leica M9 has built-in software that runs all the electrical functions. This software is known as firmware. Every so often, Leica issues an update to the firmware to fix bugs or to add extra features to the camera. You will be notified when new firmware is available after you've registered your camera. The firmware version number currently installed in your camera is shown on this menu option.

Installing new firmware

1) Insert a memory card into your M9 and format it. Switch off your M9.

2) Remove the memory card and insert it into a memory card reader attached to your PC or Mac.

3) Download the new firmware from the Leica web site from the UPDATES link.

4) Copy the downloaded file to your memory card.

5) Reinsert the memory card into your M9 and turn on the camera.

6) You will be asked whether you want to update the firmware on the LCD. Highlight **Yes** and press SET. The camera firmware will now be updated. The entire process will take about three minutes. Do not turn off your camera during this period.

7) When the firmware has been updated, you will be prompted to turn off the camera. Turn it off, then back on again and use as normal.

Warning!

You will not be allowed to update the firmware if the battery charge is low.

RIGHT PLACE, RIGHT TIME »
Carrying a camera around whenever possible means unique events can be captured that otherwise would go unrecorded. This cloud drifted across an otherwise clear sky. What appealed to me was the juxtaposition of the soft cloud and the geometric reflections it created in the glass building below.

Lens: 50mm *Shutter Speed:* 1/250 *Aperture:* f/4

White balance	Auto
Compression	DNG & JPG fine
Resolution	▦ 18MP
Exposure comp.	±0
Exp. bracketing	Off
Set user profile	-

The M9's Parameters menu allows you to control six of the most useful settings needed on a day-to-day basis: White balance, Compression, Resolution, Exposure compensation, Exposure bracketing, and Set user profile. When the M9 is set to Snapshot *(see page 99)*, Exposure compensation and Exposure bracketing are not available. The other options are fixed and you will not be able to alter the settings (see the menu summary on *pages 72–75* for full details).

Tip

*Configure your M9 to your most frequently used settings and then save these settings using **Save user profile*** (see page 78).

Using and altering settings on the Parameters menu

1) Press SET.

2) Use either ⭘ or ▲ ▼ to move up and down the menu screen and highlight the various settings.

3) Press SET to make changes to the highlighted setting.

4) Use ⭘ or ▲ ▼ to move up and down the options on the submenu and highlight the various choices for that setting. Press SET again to choose the highlighted option and return to the Main menu. Alternatively, press MENU to return to the Main menu without altering the original setting.

5) Press lightly down on the shutter-release button to go directly to Shooting mode. Alternatively, press Play to go directly to image review.

› White balance

The various settings to adjust the white balance are found here. *See page 62 for full details.*

› Compression

› Resolution

White balance	2000 K
Compression	DNG
Resolution	JPG fine
Exposure comp.	JPG basic
Exp. bracketing	**DNG & JPG fine**
Set user profile	DNG & JPG basic

White balance	2000 K
Compression	1MP
Resolution	2MP
Exposure comp.	4.5MP
Exp. bracketing	10MP
Set user profile	**18MP**

This option allows you to choose whether you shoot DNG RAW, JPEG, or both together. The advantages and disadvantages of both file types are set out on *pages 66–68.* If you have sufficient memory card capacity, shooting both together will give you the option of using the JPEG immediately and as a reference shot for the processing of the RAW file.

The quality of the JPEG compression can also be set using this option. Fine applies less compression to the file, resulting in a better-quality image. Basic applies more compression, with a greater loss in image quality, allowing you to fit more images onto the memory card. RAW files can also be compressed (*see page 90* for details).

The full resolution of the M9 is 18 megapixels. If you do not require that level of resolution, you can reduce the image size using this option. The lower the resolution, the smaller the file size on the memory card, but the less useful the file for high-quality output. As an example, at 300 pixels per inch, an 18mp M9 image could be printed to approximately 17in. by 11in. Set to 1mp, the lowest resolution, the print size at 300ppi would be 4.2in by 3in.

Note:
RAW files are always saved at the maximum resolution of 18mp.

› Exposure comp.

White balance	2000 K
Compression	DNG & JPG fine
Resolution	▦ 18MP
Exposure comp.	**+1/3**
Exp. bracketing	Off
Set user profile	-

Bracketing involves shooting three or more variations of an image at different exposures to ensure that one at least is correctly exposed *(see page 84)*. Bracketing is switched on using this option.

Note:
Bracketing is only available in Aperture Priority mode.

The exposure suggested by the M9's metering system can be overridden using Exposure compensation. The option on the Parameters menu is one of three ways that this can be achieved *(see page 50 for full details)*. Exposure compensation can be set between +/-3 stops in ⅓-stop increments.

› Set user profile

White balance	2000 K
Compression	**Snapshot profile**
Resolution	Profile 1
Exposure comp.	Profile 2
Exp. bracketing	Profile 3
Set user profile	Profile 4

User profiles are set using the Main menu *(see page 78)*. Once you've set a profile (or profiles), you can choose them using this option. The camera is then set to the saved options for the chosen profile. The Snapshot profile can also be set using **Set user profile.**

› Exp. bracketing

White balance	2000 K
Compression	DNG & JPG fine
Resolution	▦ 18MP
Exposure comp.	±0
Exp. bracketing	**Off**
Set user profile	On

› Snapshot profile

The Snapshot profile is essentially a profile set by Leica that cannot be altered or deleted. The profile locks you out of some of the image decision making process, but does make your M9 easier to use (though of course focusing and composition will still be down to you). It is not only the Main menu that is simplified in Snapshot, information in the viewfinder is also altered. The table below shows the meaning of the symbols displayed in the viewfinder.

ISO is set to **AUTO ISO** to reduce the risk of camera shake when light levels are low.

Notes:
The Main menu is restricted to just five options. The remainder are either set automatically or are not available at all.

When Snapshot profile has been activated, you can cancel at any point by pressing SET.

Snapshot viewfinder

●		Exposure is correct
●◀	(triangle flashing)	Risk of overexposure
		In Aperture Priority mode, use a smaller aperture
		In Manual mode, use a faster shutter speed or smaller aperture
▶●	(triangle flashing)	Risk of underexposure
		In Aperture Priority mode, use a larger aperture
		In Manual mode, use a slower shutter speed or larger aperture

Chapter 3
IN THE FIELD

IN THE FIELD

For some people, a successful photograph is one that is in focus and correctly exposed. And yet there is more to photography than achieving technical competency—although obviously that is important, too.

A photograph should engage the viewer somehow. This can be on a personal level, if the subject is known to the viewer; emotionally, if the photograph stirs something in the viewer; or aesthetically, when an aspect of the world's beauty has been caught in an interesting way.

The role you have as a photographer is to decide what reaction your final image will evoke. How this is achieved will be down to the creative decisions you make before you press the shutter button to create the exposure. This chapter will cover a few of the factors that need considering before you make those decisions.

The camera

All cameras are a technical compromise, and no "perfect" camera has ever been developed. Fine camera though it may be, the M9 is no exception. There are certain types of image that would be difficult to capture with an M9. Long-lens nature photography would be an impossible subject for example.

However, one of the skills of photography is learning to work within the limitations of your camera. This involves using the camera as often as possible until the controls and feel of it become second nature. It is only then that the limitations will cease to matter and the camera will become an extension of yourself and how you see the world.

FREE PERCH «
What I enjoyed about this scene is the idea that the seagull has three hours' free parking before needing to move on to another spot.

» COMPOSITION

Search the Internet for "rules of composition" and you will be presented with thousands of pages of tips and advice. Certain of the rules of composition have been known about for thousands of years. However, rigidly sticking to a formula is creatively unfulfilling. A good photographer knows about the rules of composition, but also when to break them.

Rule of thirds

Ask any photographer to name a compositional rule and more than likely the "rule of thirds" will be the first to be mentioned.

It's a very simple rule to understand. Imagine your image divided up by two equally-spaced horizontal lines and two equally-spaced vertical lines. Your subject should be placed at one of the intersection points of these lines. The idea is that this is a more dynamic arrangement than if the subject were placed exactly in the center of the image, and more purposeful than if it was placed at the very edge of the picture space.

THE EYES HAVE IT »
I deliberately followed the rule of thirds for this image, placing the eyes of this inhabitant of Stone Town, Zanzibar, on the top right intersection.

Rule of odds

Three is the magic number. Or five. But not two or four. The "rule of odds" holds that by using an odd number of subjects, you will automatically add balance to an image. Whichever subject is in the middle of the arrangement is framed by the subjects on the outside.

For psychological reasons, we find this sort of arrangement more pleasing than when there is an even number of subjects in a scene.

Viewpoint

Always shooting from eye level is a trap that it is so easy to fall into, because it's a natural position to shoot from. It always pays, however, to try to discover a different viewpoint.

If your subject is close to the ground, get down and shoot from that viewpoint. This will help to add intimacy to your photo. If you can find height, shooting from above your subject will present a more emotionally remote, detached feel.

Simplifying

If an image is too cluttered, it will be difficult to know where to look. Before shooting, think carefully about who or what is the subject of the picture. When you've decided that, think carefully about the subject's background. The simpler the background, the more easily your subject will be discernible in the final image. If a background is too distracting, move position (or your subject if possible) to find a different viewpoint.

After that, look carefully around the borders of the bright line frames in the viewfinder. Is there anything around the frame lines that will intrude into the picture space when you press the shutter-release button? If there is, will it be distracting?

Using a long lens with the aperture wide open is a good way to simplify an image. It will require precise focusing on your subject, but the space around the subject will be out of focus and therefore simplified.

PRAGUE FROM **«**
ABOVE
Tall buildings with accessible windows or balconies allow you to look down to create an unusual viewpoint of a city.

Symmetry

There is something very pleasing about a perfect reflection. A reflection is a symmetry, and symmetries evoke calm, peaceful thoughts. This idea can be played with. Adding an element that creates an asymmetry will therefore create tension within a composition.

It is not just reflections that create symmetries. Symmetrical compositions can be found elsewhere in nature, as well as in artificial environments. Though symmetrical arrangements are pleasing, it doesn't pay to use the device too often. Repeat the trick over and over, and your images risk looking contrived and stale.

Balance

A photograph has balance if visually both halves have equal weight. This does not necessarily mean that the image should be symmetrical. Some subjects contribute more visual weight than others.

A person, for example, has a lot of visual weight. Our eyes tend to gravitate to a person in a photo regardless of

how small they are in the picture. Therefore, if a person is in an image, it would take something equally eye-catching on the other side to "balance" the picture. Size is one way to add weight, and color is another. Red is very heavy visually, far more than blue or green. Adding an element that combines these two qualities will provide a lot of visual weight. Just be careful not to go too far.

LOOKING OUT »
The face at the window is a visually "heavy" part of this image; fortunately, there was an old bicycle outside that helped to balance the picture.

Depth

Conveying depth in an image is always a challenge. We rely on visual clues to perceive depth in the real world, so you need to be aware of these clues and use them in your images.

The atmosphere is thick with particles of dust. These particles gradually reduce the apparent contrast of objects as their distance from the camera increases. As well as contrast, the saturation in the color of objects is reduced, and the overall color shifts toward the background color. In landscapes, this is often blue-gray. This depth cue is known as aerial perspective and has long been used by landscape painters to convey depth.

Perspective is another powerful way to convey depth. We instinctively know that parallel lines appear to converge toward a vanishing point. Finding a composition that triggers those instincts will immediately convey depth.

Diagonal lines

A diagonal line has more visual energy than a horizontal or vertical line. The latter can look passive and uninteresting, particularly when placed directly across the middle of an image. A diagonal line,

even when it is only implied, looks as though it's going somewhere, creating an impression of dynamism.

Leading Lines

The eye likes to follow a line. Finding some element of a scene that leads the viewer through the picture is a powerful way to direct their attention. Placing your subject at the end of the line will be a reward for the viewer after their journey through the image.

LINES ON A BEACH »
These furrows in the sand help to convey a powerful sense of depth in the image.

» LIGHT

Without light, there would be no photography. How your subject is lit will affect the success—or not—of your photograph. Learning to judge, and correct if need be, what light most suits the subject of your image is one of the fundamental skills that needs to be learnt to progress as a photographer.

Light sources

Unless you work entirely in a studio, the sun will be your primary light source. As sunlight enters the earth's atmosphere, it is partially absorbed and scattered. The different wavelengths of sunlight are absorbed and scattered to different degrees. The shorter the wavelength—the blue part of the spectrum—the greater the scattering and absorption. The higher the altitude you shoot, the less atmosphere, so

the more intense and blue the light will become.

Even at sea level, the sun's rays pass through less atmosphere at midday than they do at sunrise or sunset. At the ends of the day, sunlight passes more obliquely through the earth's atmosphere. This cuts out more blue light than at midday, resulting in the "warmer," redder light that we associate with sunrise and sunset. Contrast is also reduced at this time of day, although it quickly rises as the sun increases its height above the horizon.

In the tropics, the length of the day and the height the sun rises do not vary much throughout the year. The farther north or south you travel, the greater the seasonal variation. In the summer months at midday, when the sun is nearly vertical in the sky, the light will be almost neutral in

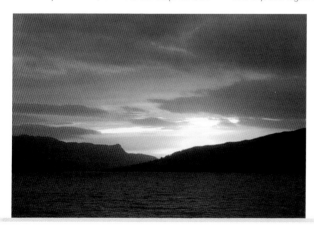

WARM COLOR　**«**
The sun's light is warmest at dawn and dusk, and for this reason, these are often the favorite times of landscape photographers.

color. In winter, the sun rises less high during the day. Even at midday, the sunlight can be very "warm" in color, even though it may not be warm in temperature *(see page 62)*.

Contrast

The contrast of a scene is the difference between the darkest and the brightest tones. The greater the difference, the greater the contrast. The human eye is remarkably adept at coping with scenes of high contrast. Unfortunately, camera technology has not advanced to the same level of ability.

In the natural world, contrast is highest at noon on a cloudless day. If cloud even partially covers the sun, contrast will be much reduced. If the day is overcast or misty, contrast is far lower still.

Certain subjects suit high contrast. Very graphic black-and-white photography suits a high-contrast approach. Modern architecture often benefits from this way of shooting, as does punchy, gritty portraiture. Natural subjects such as flowers or a more flattering style of portraiture are suited to the softness of low-contrast light.

What often leads to disappointment is trying to force a particular way of shooting with the wrong light. If the light is not favorable for one subject, change to a more suitable subject or find ways to alter the contrast. Ultimately, there is never bad light, only bad photography.

Coping with high contrast

For smaller subjects, use a reflector to "throw" light back into the shadows. Reflectors can be bought commercially and generally fold up to fit in the pocket of your camera bag. Using a golden reflector will also add warmth to the light. For larger subjects, high dynamic range (HDR) is one method of creating more tonal range. The M9 can be set to bracket shots *(see page 84)*. Alternatively, an external flashgun or lights can be used, again to throw light into the shadows. ND graduated filters *(see page 218)* are often employed by landscape photographers as a means of balancing the exposure difference, mainly between the sky and foreground.

Lighting direction

It is not just the softness or hardness of light that you need to consider. The direction light comes from and how it illuminates your subject will have an effect on the success of your image.

STORMY LIGHT »
Despite the overcast conditions, the contrast levels were too high for the camera to record all the tones in the scene. I used a two-stop ND graduated filter to balance the lighter sky with the darker foreground.

Frontal lighting

Lighting your subject directly from the front will ensure that it is evenly lit. However, this is not necessarily a good thing. Flash light directly from a camera is a good example of frontal lighting. The results are rarely flattering: the subject often looks flat, as though they've been "cut out" from the scene. This is because the texture and form that give a subject shape, are supplied by shadow. With frontal lighting, the shadow areas will be behind the subject and therefore out of view of the camera.

Because frontal lighting is even, it is very easy to achieve a good exposure.

However, that's probably the best thing to be said about it.

Side lighting

If you move a light source to either side of your subject, immediately form and texture become more apparent. This can create problems with contrast. With a point light source, deep shadows may result if there is no "fill-in" light. This can be as simple as using a reflector to bounce light back into the unlit side of the subject, or as complex as using a secondary light. The key is not to overpower the main light source so that the subject looks flat. Too much contrast control is almost as bad as too little.

Backlighting

A backlit subject is one that is lit from behind, with the source of illumination facing the camera. By the nature of the lighting, your subject could potentially be rendered as a silhouette. If the shape of your subject is strong, this can produce very

AFTER SUNRISE 〈〈
The ends of the day produce natural side lighting. Clouds in the sky help to keep the contrast levels manageable by bouncing light back into the shadows.

effective and dramatic images. If you do not want a silhouette, you will have to employ contrast control to throw light back toward your subject. Again, you will have to balance the light from the front so that it does not overpower the light from behind. Low-powered flash is ideal for this, as is a large reflector board.

Backlighting is particularly effective for portraiture. Hair that is backlit will take on an appealing glow that helps to frame the face. Translucent subjects also benefit from backlighting; the color of the subject will be more intense and any fine detail that is normally hidden will be revealed.

Flare can be a problem with backlit subjects. If possible, keep any direct light from shining straight into the lens. If the light is slightly off to the side and the background behind the subject is dark, this may cause overexposure. Apply exposure compensation if necessary. Often 1–2 stops may be necessary depending on the level of the background's darkness. The darker it is, the more exposure compensation may be required.

BOTTLES ⩔
In the natural world, backlighting is seen most often at the ends of the day, when the sun is low in the sky.

» COLOR

How you use color in an image will go some way to conveying the emotional mood of the piece. Different colors evoke different emotions. Blues and greens are very restful colors. Green is found in abundance in the natural world and so is associated with nature, freshness, and tranquility. Reds and oranges are less restful, and have more visual energy and weight. A small splash of red in a picture is far more immediately apparent than an equally sized patch of blue or green.

When colors are combined in an image, the result can be harmonious or complementary.

• **Harmonious colors** lie close to each other on the standard color wheel. Red, orange, and yellow in combination would produce a harmonious color scheme. Harmonious color schemes are balanced and inherently pleasing.

• **Complementary colors** lie on opposite sides of the color wheel to each other. Blue and yellow are complementary, as are red and cyan. Complementary colors have the effect of making each other appear brighter and more vivid. The result is not restful, but the combination is dynamic and effective. Happily, complementary colors occur in nature. At sunrise and sunset, the light is often yellow, whereas shadows, lit by the ambient light from the sky above, are often blue.

Top left: Green is a calming ›› color, associated with nature and growth.

Top right: Autumn brings fiery red, a vibrant and visually dominant color.

Bottom Left: Yellow and blue are complementary, and enhance the vividness of each other.

Bottom right: Blue and green harmonize well.

COLOR WHEEL ‹‹
Neighboring colors are harmonious, opposing colors are complementary.

3 » BLACK-AND-WHITE

Color vision evolved to allow us to distinguish certain cues in nature. For example, plants and animals often use red or yellow coloring to signify that they would be dangerous to eat. The art of black-and-white photography is seeing "reality" in a less literal way, to use the tones and contrast of a scene rather than color to define the emotional and visual impact of your image.

Creating a black-and-white photo involves converting the colors in a scene to shades of gray. It is up to you to decide how dark or light a tone each separate color will become.

This is more important than you may immediately think. In a color image, red and green bell peppers are distinctly different. Convert that image to black-and-white, however, and both peppers would become a mid-gray tone and so would be indistinguishable.

To visually separate the two peppers, one color must be converted so that tonally it is either darker or lighter than the other. Before digital photography, this was achieved by the use of colored filters fitted to the lens. For example, a red filter allows red wavelengths of light through, but blocks others. This would have the effect of lightening the tones derived from the red pepper and darkening those from the green pepper.

ANGEL OF THE NORTH, GATESHEAD, UK «
As a color photo, the three colors are vibrant and easily distinguished from each other.

Top left: A "straight" conversion in which all the colors were given equal priority. Tonally, there's not much difference between » the blue sky, statue, and foreground grass.

Top right: Converted simulating a blue filter. This has rendered the red and green dark gray, and lightened the blue of the sky.

Bottom left: Converted simulating a green filter. Similar to the first conversion, although the grass is appreciably lighter in tone.

Bottom right: Converted simulating a red filter. The blue sky is far darker, helping to add contrast to the clouds. The red color of the statue has been rendered lighter than the foreground grass.

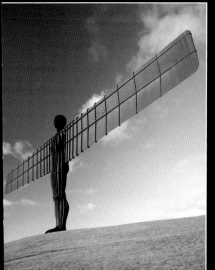

It is all too easy to be distracted by the "narrative" of a scene, so that you create a literal interpretation of what you see. However, with careful framing, focusing and creative use of depth of field, a more abstract version of "reality" of nature can be captured. This is particularly effective when using color as a subject in its own right.

Settings

> *Lens:* 50mm
> *Aperture:* f/2.8
> *Shutter speed:* 1/160 sec.
> *ISO:* 160

WATERCOLOR «
I wanted to create an abstract color image after seeing a variety of ripe fruits in a greenhouse. By focusing on the condensation on the glass of the greenhouse and using a small aperture, I was able to render the fruit farther back purely as blocks of color.

» BLACK-AND-WHITE

There are many ways of interpreting the world when creating black-and-white images. Although you can shoot black-and-white photos directly in the M9, using post-production techniques will expand the possibilities open to you.

Settings
> *Lens:* 90mm
> *Aperture:* f/11
> *Shutter speed:* 1.5 sec.
> *ISO:* 160

SPLIT-TONING «

Split-toning is the technique of toning the highlights of a black-and-white photo one color and the shadows a different color. Lightroom allows you to do this easily in the Develop module. It works most effectively when the highlight color contrasts with the shadow color. In this image, the highlights are warm toned, the shadows more coolly toned.

3 » DEPTH OF FIELD & HYPERFOCAL DISTANCE

The aperture in the lens controls the amount of light that is allowed to fall inside a camera. As the size of the aperture is reduced, it also begins to focus the light, creating a zone of sharpness around the point of focus known as depth of field. The smaller the aperture, the greater the size of the depth of field.

Depth of field always extends farther back from the point of focus than in front. There are three factors that affect the potential size of the depth of field. The aperture you use is one. Another is that the longer the focal length of a lens, the less depth of field you will be able to achieve at any given aperture. Finally, the closer the focus point to the camera, the more depth of field diminishes. This can be problematic when shooting macro subjects in particular.

Hyperfocal distance

To maximize the depth of field of a lens the focus point needs to be set to the hyperfocal distance. This is the point where everything from half the hyperfocal distance to infinity is sharp. The depth of field scale on your lens is designed to help you achieve this.

First set the desired aperture on the lens. Next set ∞ on the focus ring to the same aperture mark on the right of the depth of field scale. The focus point will now be set to the hyperfocal distance. This will mean that the focus point will not necessarily be where your subject is, so you will need to ignore the split-image in the finder, since it may not be aligned with your subject.

Tip

Although the depth of field scale on a lens is generally accurate it pays to be conservative. For example, if you set the lens to f/16, focus ∞ at the f/11 mark on the depth of field scale. This will ensure that depth of field definitely covers half the hyperfocal distance to ∞.

Top left: Small apertures (in this example » f/16) are traditionally used in landscape photography to ensure front-to-back sharpness.

Top right: Using a large aperture (f/2.0) helps to simplify a composition by rendering large areas of the image out of focus. Close focusing on a subject produces the minimum depth of field and therefore the greatest simplification.

Bottom: The eye doesn't like to linger over areas in an image that are out of focus. This helps to maximize the impact of the main subject of the image.

IN THE FIELD » DEPTH OF FIELD & HYPERFOCAL DISTANCE

3 » SHUTTER SPEED

It's a problem that has puzzled visual artists for millennia: how do you convey a sense of movement in a flat image? The invention of photography redefined how we see the world, allowing glimpses of moments in time that had previously been unimaginable.

Longer shutter speeds

The first photographic plates were incredibly insensitive to light, so that subjects had to be still for minutes, even hours at a time. Anything that moved during the exposure would be lost in an impressionistic blur.

The sensor in the M9 is incredibly responsive to light in comparison, almost to the point where it is actually difficult to use long shutter speeds for effect unless light levels are low or an ND filter *(see page 215)* is used.

Anything that moves during a long exposure will inevitably become blurred. The faster the subject, or the longer the exposure, the stronger the effect. If you also include elements in an image that don't move, this will add visual contrast.

Freezing action

As well as revealing what happens over a long period of time, photography also showed the world at tiny fractions of a second. With a modern, high-quality digital sensor, the M9 can shoot at a blistering 1/4000 of a second. That is fast enough to freeze all but the swiftest of movements.

To achieve a fast shutter speed, you will need to employ a relatively wide aperture or a high ISO. Use hyperfocal distance so that you do not need to think about focusing. You will also need to learn to anticipate rather than react to events. If you press the shutter-release button a fraction too late, the moment, as well as the opportunity, will be lost.

Top: Using a long shutter speed (0.5 sec. » for this picture) helps to convey less tangible weather conditions, such as wind, here blowing through the leaves of a tree.

Bottom left: The wash of a boat throws up a cascade of water droplets. In order to "freeze" this motion in the photo, I had to employ a shutter speed of 1/800.

Bottom right: This image required a different approach. I wanted to convey how the water eddied near the bank of a river. A shutter speed of 10 sec. caused foam on the river to form trails as it swirled past during the exposure.

Dynamic range and clipping

Photography is often a process of overcoming the limitations of a camera. One of those limitations is dynamic range. The human eye is very adept at handling a wide contrast range. A camera cannot deal with anywhere near the same contrast range. The number of tones that a camera can distinguish and successfully capture, from darkest to lightest, is known as its dynamic range.

The higher the contrast of a scene, the more likely it will exceed the dynamic range of a camera. A "straight" exposure is often a compromise between retaining detail in the shadows and detail in the highlights.

There are certain ways to overcome the limitations of a camera's dynamic range. One method is to use neutral density (ND) graduated filters (see page 218) to "hold back" the exposure of one area of a scene to match that required by another. Another approach is to bracket a series of images (see page 84) and blend them together as an HDR merge, using software such as Adobe Photoshop.

When tonal information, either in the shadows or highlights, has exceeded the dynamic range of a camera, it is referred to as being "clipped." The M9 can be set to warn visually when information has been lost this way during image review (see page 58), although learning how to read a histogram (see page 52) is a more useful and accurate way of assessing an image.

Noise

In a digital image, noise is texture or detail caused by the camera that was not present in the original scene. There are two types of noise, luminance and chroma. Of the two, luminance is more acceptable. It is seen as random variations in the brightness levels of pixels, most visibly in large areas of even tone, such as sky. However, it often has a pleasing "film grain" look that can make a digital image look less sterile.

Chroma noise is less aesthetically pleasing and is seen as random spots of color across an image. Both types of noise can be reduced in Lightroom (see page 190). However, this is achieved at the cost of reducing fine detail.

The higher the ISO (or the more you increase the exposure of an image in post production), the greater the amount of noise. For maximum quality, it is recommended that the lowest ISO, without risking camera shake, be employed. Use the histogram to avoid underexposure and even, if possible, expose to the right (see page 52) to gain maximum detail in shadow areas.

JPEG artifacts

The JPEG format works by compressing images to make the file size smaller *(see page 66)*. However, this compression is achieved by reducing the fine detail in an image. The greater the compression, the greater this loss (JPEG is known as "lossy" compression for this reason).

NOISE IN HEAVENS ✕

Having set the camera to a high ISO to capture a night sky at a relatively fast shutter speed, I found that this image displayed both luminance and chroma noise.

3

Sharpness

Most digital cameras have an anti-aliasing (or low-pass) filter over the sensor. This is used to reduce the effect of moiré, which is seen as interference patterns caused by repetitive details that exceed the resolution of the sensor. However, the use of an anti-aliasing filter causes an image to soften slightly, requiring sharpening to some degree after capture. The M9 does not have an anti-aliasing filter, so the images are usually acceptably sharp already (other than in areas that are out of focus or when lack of sharpness is caused by camera shake).

However, some sharpening still has to be applied to an M9's images when displaying them either in print or onscreen. This is achieved by increasing the acutance in the images. Acutance is the contrast between edges in an image. The higher the acutance, the greater the contrast. A high acutance results in

an image looking sharper. However, apply too much acutance, and distinctive and ugly light and dark halos form around the elements of your images.

Sharpening can be applied in-camera to JPEG images *(see page 82)* or by using software such as Lightroom. Generally, an image needs more sharpening for print output than screen, although the level of sharpening required will also depend on the final size of the image and the distance from which it will be viewed.

Images with heavy JPEG compression should not be sharpened. Sharpening will increase the visibility of the compression artifacts still further.

TOO SHARP FOR COMFORT »
This image has been over-sharpened, which is particularly noticeable in the sky and shadow areas.

» OPTICAL PROPERTIES

Flare

Lens flare is a generally unwanted result of light reaching the sensor (or film) that has been scattered by internal reflections from the glass elements of a lens. Flare is seen as streaks and blobs of color across an image, or as a partial or complete reduction in the contrast of the image. It is most often caused by a strong light source shining either directly into the lens or obliquely into the lens without appearing in the image itself.

There are various techniques that can be employed to reduce the effects of lens flare. The use of a lens hood will stop or reduce light entering the lens obliquely. All current Leica lenses include a lens hood, which can be left on permanently unless you intend to fit a third-party filter system *(see page 213)*. Keeping the lens glass clean is important. The presence of greasy fingerprints or dust increases the risk of flare as well as potentially reducing the quality of your images.

"Coated" lenses have one or more microscopic layers of anti-reflective coating on their glass surfaces. This helps to reduce internal reflections in the lens and thus flare. Pre-1970s Leica lenses that were once coated may have had their coating gradually worn away over time. If you intend to buy an older secondhand Leica lens, bear in mind that it may be more prone to flare than a modern lens.

We don't "see" flare the way a camera does, so it could be argued that including flare in an image will make it less "real." However, flare is more acceptable or even expected thanks to the willingness of moviemakers to deliberately include it in effects shots. Therefore, don't be afraid to include it in your images for creative effect.

FAVORABLE FLARE »
Rain in the lens caused problems with flare in this shot. However, I like the effect and so regard its occurrence as a "happy accident."

Distortion

Lens distortion is usually seen as the curving or bending of ostensibly straight lines in an image. There are two main types of distortion created by a lens: pincushion and barrel. Pincushion results in straight lines bowing in toward the center of an image; barrel is the bowing of straight lines out from the center.

Leica lenses are renowned for being distortion free (or as close as it's technically possible to get), so distortion will not be noticeable on most images. Older or third-party lenses may suffer more distortion, but usually this can be eliminated by the use of imaging software such as Adobe Photoshop.

Chromatic Aberration

Also known as achromatism, chromatic aberration (CA) is caused by the inability of a lens to focus all the different wavelengths of light at the same point. This results in colored fringing at the boundaries between light and dark areas of an image. Chromatic aberration is usually either green-red or yellow-blue.

There are two types of chromatic aberration: axial and transverse. Axial CA can be seen across the whole of the image when the aperture is wide open, but is greatly reduced as the lens is stopped down. Transverse CA is seen in the corners of images and is not reduced by stopping a lens down.

Transverse CA can be corrected using Lightroom's Chromatic Aberration panel in the Develop module *(see page 190)*. Axial CA is more difficult to correct and is only really avoided by not using the maximum aperture of a lens.

LIGHTROOM **«**
Correcting Chromatic Aberration in Adobe Lightroom.

Vignetting

The photodiodes on a camera sensor need light to fall perpendicularly into them to ensure optimal collection of light during exposure. However, the light rays coming from the edge of a lens are usually bent more, and therefore less perpendicular, than those passing through the center. This means that the photodiodes at the corners of the sensor receive less light than those at the center, causing underexposure or vignetting at the periphery of images. The M9 uses offset micro-lenses on the sensor photodiodes to help reduce this problem by "rebending" the light so it is more perpendicular.

Wide-angle lenses are more susceptible to vignetting than telephotos, although all lenses will display some vignetting at maximum aperture. However, the more a lens is stopped down, the less likely will be visible vignetting.

Vignetting can be corrected in post-production using Lightroom, but this correction can cause other problems, such as introducing noise into the lightened areas of the image.

A different, but similar, problem is darkened corners caused when a lens hood or filter holder appears in the corners of images. This is most likely to occur when using a wide-angle lens. To prevent this, some filter holder manufacturers make special wide-angle lens adapters for their systems that bring the filter holder closer to the front of the lens.

VIGNETTE **《**
There is vignetting visible in this image, but I chose not to correct its effect. The darkened corners help to guide your eye toward the droplet in the center. Vignetting can be used creatively, despite being technically "incorrect."

» WORKING WITH DIGITAL IMAGES

The temptation with a digital camera is to overshoot and create more images than is strictly necessary. After all, each image is essentially "free," without the processing costs associated with shooting film. In many ways, this is a good thing, since the freedom encourages a more experimental approach to photography.

The big drawback to this approach comes when you copy the images to your PC and are faced with the Herculean task of editing the good from the bad. A good discipline to acquire is to edit as you shoot. That is, think carefully about the photograph before you press the shutter-release button. Ask yourself if you would be happy to spend time editing the image in post-production. Although digital files are free, time is precious, and time spent editing at a computer is time when you could be out practicing your photography.

At this point, therefore, you may be thinking that deleting images that don't "work" during a photoshoot is a good idea. However, unless an image is very definitely a technical failure, this is not a good habit to acquire. Some images immediately leap out as being successful. Others are subtler and defy instantaneous appraisal. Often it's these images that tempt deletion. However, don't rush to discard them. Give all your images a chance by returning to them after a day or so for more considered judgment.

STARING CONTEST »
This was one of the final images from a busy day's shooting. Although it was created on the spur of the moment, I actually prefer it to some of the more considered images from that day. It could so easily have been rejected as a "snap" and therefore not worth keeping.

File naming

Just because your camera has assigned a file name to an image does not mean that you have to keep it. It's good policy to develop a file naming system that is meaningful to you, but that will never repeat. One way to do this would be to include the month and year in the file name as well as a file number.

So, for example, a file called 1110_0045 would be image number 45 created in October 2011 (putting the year first makes it easier to sort files chronologically in a folder). In conjunction with good folder management and keywording *(see following page)*, this is a powerful way to keep track of your images.

Filing systems

No matter how parsimonious you are in creating images, inevitably you will start to build up a collection of images on your PC's hard drive. The easiest solution is to create a folder called photography and copy everything into it. Don't! This is just storing up trouble for the future. With ten images, it is easy to find the one you want. With ten thousand, it becomes an impossible task.

FILES »
Searching for a particular image would be virtually impossible without a disciplined approach to file management.

Start by creating a logical and expandable way of filing your photos. One way is to create a master folder and then divide it into subfolders for specific categories of image. These subfolders can be divided still further into even more specific subcategories and so on.

> ### *Tip*
>
> *If you are using a Mac, Time Machine can schedule a backup of your hard drive at regular intervals. Super Duper is an excellent third-party alternative (www.shirt-pocket.com). Windows 7 is supplied with Backup and Restore; and Oops!Backup is a well-regarded commercial alternative* (www.altaro.com).

It is good policy to backup your images using this folder structure on a regular basis. Hard drives are not infallible and can fail without warning. Large-capacity external hard drives are relatively cheap, and many come with software to help establish a painless backup routine. For further peace of mind, maintain several hard drive backups, keeping at least one drive offsite, and swap the drives around at least once a week.

WESTERN DIGITAL ⌄
My Book Essential External Hard Drive.

© Western Digital Corporation

Keywording

If you use digital asset management (or DAM) software or intend to supply stock photography libraries with images, it is good practice to keyword your images. Lightroom makes this easy, allowing you to apply keywords to your images at the import stage as a batch or more selectively in the Library module *(see page 182)*.

The most important keywords are those that describe the subject of the photo itself. If you want to keyword a landscape photograph, location details would be important. These would include the specific place name as well as finer details of the image content. Important portrait keywords would include the name of the subject, sex, facial expression, and potentially even ethnic background.

Keywords that describe the emotional or conceptual content of photos are often used by image library clients searching for images. This requires careful thought so that the keywords aren't misleading. Think carefully whether your photo has positive or negative connotations. The subject should give you some guide to this as will the color palette of your image. Cool colors, such as blue or green, are more readily associated with negative emotions than reds or yellows.

Digital asset management

Once you've added keywords to your images, they can be used as search terms in an image database created using DAM software. There are several packages available for both Windows PCs and Mac OS X. They range from comparatively simple software, such as Picasa by Google, to full-blown, professional systems, such as Expression Media 2.

Good DAM software should cope with tens of thousands of files quickly and efficiently, and allow searches based on keywords, image ratings, or labels (all of which can be set in Lightroom). Some DAM software now even supports facial recognition. Once the software has learned a particular face, it can be used as an effective method of searching for a particular image.

An alternative to DAM software that is installed on your PC or Mac is to use a system that allows you to store your images online. This has the advantage that your images are stored offsite and so are less likely to be lost due to hard drive failure. Companies that provide this service usually charge a monthly or yearly fee, the price often dependent on how much storage space you require.

Some companies, such as photoshelter. com, offer the option of allowing others to search through your images with a view to buying the rights to use an image directly from you. If you market this facility on a personal website, it can become another revenue stream, which at the very least may pay for the file storage costs.

EXPRESSION MEDIA 2 »

Wide-open spaces are often difficult to photograph. With acres of empty space, there is nothing with which to fill the foreground. Filling the foreground isn't something you need to do for every shot. Indeed, it could look contrived if you repeat the device endlessly. However, a good foreground does help to draw the viewer into your shot and prevent their eyes from wandering aimlessly, looking for something of interest. Getting down low and using a wide-angle lens is a good way to make the foreground feel a vital part of your picture.

Settings
› *Lens:* 24mm
› *Aperture:* f/16
› *Shutter speed:* 0.5 sec.
› *ISO:* 160

COUNTY DOWN, NORTHERN IRELAND ⌄

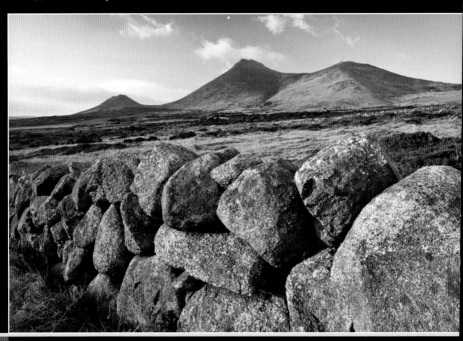

» A MOMENT IN TIME

One of the joys of photography is seeing the world in a manner that was impossible before its invention. There are many ways to achieve this. One of these is to employ shutter speeds to capture a sense of movement in a scene. Using a fast shutter speed will "freeze" motion. Using a long shutter speed, as in this picture, allows us to see the path of a subject's motion as an ephemeral blur. This technique is most effective when there is something immobile in the photograph to act as a counterpoint to the motion.

NORTHUMBERLAND, UK ⋁

Settings
› *Lens:* 28mm
› *Aperture:* f/16
› *Shutter speed:*
 1 sec.
› *ISO:* 160

STONE TOWN, ZANZIBAR ⌄

Portraits with the greatest visual impact are generally those where the subject is looking directly into the lens. Some people are intimidated by the idea of having their photo taken. This often results in them looking away from the camera, an unconscious submissive gesture caused by their unease. As the photographer, it is up to you to win your subject's trust. This is only achievable if you empathize with your subject. If your subject is a stranger, smile and be polite. Use humor if possible and reassure them that you don't want to show them in an unflattering way. When you're finished, be prepared to show your subject the final picture on your camera's LCD.

Settings
> *Lens:* 50mm
> *Aperture:* f/4
> *Shutter speed:* 1.50 sec.
> *ISO:* 400

» ABSTRACTION

It is sometimes difficult to create new and interesting images of familiar scenes. As the saying reminds us, "Familiarity breeds contempt." To be successful photographers, we need to be able to see beyond the everyday and look at well-known subjects in a different manner. One way to achieve this is to take a more abstract approach, not seeing a scene as a "whole," but looking for interesting vignettes and details. In this example, I saw the potential of creating an image of a local sports stadium in its reflection in a nearby glass-fronted office building. This was achieved by wandering around with an open mind, looking not only at the subject, but also at its surroundings.

Settings

> *Lens:* 135mm
> *Aperture:* f/16
> *Shutter speed:* 1/10 sec.
> *ISO:* 160

NEWCASTLE-UPON-TYNE, ENGLAND

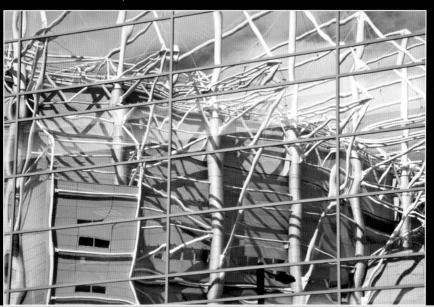

Chapter 4
LENSES

4 LENSES

Leica has a justifiable reputation for producing the sharpest commercial lenses available for any camera system. The choice is not limited to modern lenses either. Because the M-mount has been in use since 1954, there is a wealth of lenses available secondhand that are compatible with the M9. Don't dismiss a lens that dates from the middle of the last century—if it's in good condition, it should prove to be a match for anything you can buy new today.

The history of Leica lenses is a convoluted story, one that is too long for this book. This chapter, therefore, is only a guide to what is currently available new, both from Leica and third-party manufacturers. For the curious, the Internet is a good resource for information about lenses that are out of production, but that are still available on the secondhand market.

M39 Lenses

The Leica M-mount followed on from the Leica M39 standard used on Leica cameras before 1954. The M39 mount is a screw mount with a 39mm thread. Cameras produced by Voigtländer still use this mount today, so there is a plentiful supply of both new and secondhand M39-mount lenses. If you are willing to experiment with older lenses, adapters can be used with the M9 to allow you to mount M39 lenses to your camera. Suitable adapters can be purchased from manufacturers such as Photodiox.

STANDARD LENS ⌃
Leica M9 and Summilux 50mm 1.4 ASPH lens.

SPLASHES OF LIGHT »
Patience is often a virtue with landscape photography. Setting up your camera on a tripod allows you to wait and watch for the light to illuminate your subject in the most pleasing way possible.

» THE LEICA RANGE

Leica produces a wide range of lenses that are compatible with the M9. At first sight, there appears to be a lot of duplication in the lineup, with two, three, even four lenses sharing the same focal length. The difference between these lenses is the maximum aperture of the lens. Leica uses a naming convention to help you distinguish between these lenses.

› Noctilux

There is only one current Noctilux lens in the Leica range, the NOCTILUX-M 50mm. Weighing 24.6oz (700g), it is also the heaviest lens. This is due to its maximum aperture of f/0.95, making it the fastest Leica lens you can buy. Not coincidentally, it is also the most expensive lens Leica produces. "Nocti" is derived from nocturnal, "Lux," is the Latin for light, a reference to its astounding light gathering capacity. Older Noctilux lenses, superseded by the current design, have maximum apertures of f/1.0 and f/1.5.

› Summilux

Less expensive than Noctilux lenses, the Summilux are still respectably fast lenses. With maximum apertures of f/1.4, they are one stop slower, but are less weighty and far less expensive.

LEICA APO-SUMMICRON-M 90mm f/2 ASPH

› Summicron

The maximum aperture of Summicron lenses is f/2.0. The name is taken from the 50mm Summar, a lens introduced in 1933 and Krone, the Danish for Crown (in the 1950s, Leica bought Crown glass from an English company and used it to make the Summicron lenses).

› Summarit

Lenses in the current Summarit range have a maximum aperture of f/2.5. Older Summarit lenses have a maximum aperture of f/1.5, but the Summilux name has superseded this older usage.

› Elmar

Originally, lenses designated Elmar had a maximum aperture of f/3.5. Elmar lenses were derived from a 50mm f/3.5 Elmax lens first produced in 1925 (the name taken from Ernst Leica and Max Berak). Current Elmar lenses in the Leica range are either f/3.8 or f/4, as in the ELMAR-M

24mm f/3.8 and TRI-ELMAR-M 16-18-21mm f/4. Because Elmar lenses are comparatively slow, they tend to be smaller and lighter than faster lenses of the same focal length.

› Elmarit

A derivation of Elmar, Elmarit lenses have a maximum aperture of f/2.8. Confusingly, not all f/2.8 lenses are Elmarits. The 50mm f/2.8 "collapsible" lens, manufactured until 2007, was designated as Elmar rather than Elmarit.

LEICA SUMMARIT-M 50mm f/2.5 ⌃

» LENS TECHNOLOGY

Leica uses a number of acronyms and abbreviations to describe the technology used in their lens range. The following table explains these terms.

› ASPH: Aspherical

Light passing through a non-aspherical lens is not focused evenly across the lens image circle. Typically, the edges of a non-aspherical lens focus light at a different distance to the center of the lens, resulting in either the corners or center of an image being sharp, but not both. The glass in an aspherical lens is shaped to help to focus light evenly across the entire lens.

› APO: Apochromatic

Chromatic aberration is caused by different wavelengths of light not being focused evenly at the same point. This results in color fringing, particularly around areas of light-to-dark transitions. APO lenses employ low-dispersion glass to reduce this problem.

› TELE (TELYT): Telephoto

The longer the focal length of a lens, the longer and heavier it will be. Telephoto lenses are physically shorter than their focal length would suggest. This is achieved by the use of lens elements (known as the telephoto group) that extend the light path within the lens to create a longer focal length lens in a shorter "package."

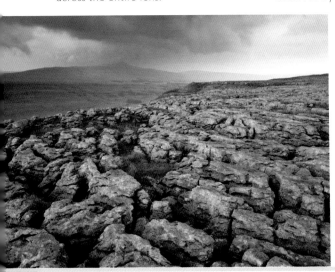

WIDE LANDSCAPE 〈〈
The use of a 28mm lens helps to emphasize the sweep of the rocky foreground.

› Third-party lenses

Although Leica originated the M-mount, over the years other manufacturers have produced lenses for the standard. Carl Zeiss and Voigtländer are the two lens makers most closely associated with third-party M-mount lenses.

Carl Zeiss was founded in 1846 in Jena, Germany. The company is renowned for producing quality optics for applications such as medical imaging, astronomy, and of course photography. As well as making M-mount lenses, Carl Zeiss supplies lenses for camera systems such as the Nikon F-mount, Canon EOS, and Sony.

Voigtländer is even older than Carl Zeiss, the company being formed in Vienna in 1756, thus predating the birth of fixed-image photography. Voigtländer has had a slightly more checkered history than Carl Zeiss, being sold to Rollei in 1973 and then to Plusfoto in 1982. Today Voigtländer lenses are made and marketed by the Japanese company Cosina.

Both companies produce lenses with focal lengths that are not produced by Leica, such as the extremely wide-angle 12 and 15mm Heliar lenses made by Voigtländer. The one drawback is that the basic M9 viewfinder will not be as effective with lenses that do not match the bright line frames. A supplementary viewfinder therefore will need to be used.

For a full list of current Carl Zeiss and Voigtländer lenses, refer to the table on *pages 154–155.*

CARL ZEISS LENSES ≫
A selection of lenses from the Zeiss range.

© Carl Zeiss AG

› Focal length

The focal length of a lens is defined as the distance in millimeters from the optical center of the lens to the focal plane when the lens is focused on infinity. The focal plane is where the sensor of the M9 is located. With the exception of the TRI-ELMAR-M 16-18-21mm, all Leica lenses are of a fixed focal length. The longer the focal length of a lens, the greater the magnification of an image, but the narrower the angle of view. The opposite applies as the focal length becomes shorter.

› Angle of view

The angle (or field) of view of a lens is the angular extent of the image projected by the lens and recorded by the film or sensor in a camera. The angle of view is expressed in degrees (°) and typically refers to the diagonal coverage of the lens, although both horizontal and vertical aspects are occasionally used (and should be noted as such).

The angle of view is dependent on the focal length of a lens and the size of the image-recording surface. The angle of view of a short-focal-length lens is wider than that of a long lens, so short-focal-length lenses are referred to as wide-angle lenses. The smaller the sensor in a camera, the narrower the angle of view captured. The Leica M8(.2), the M9's predecessor, has a sensor that is a third smaller than that in the M9. The diagonal angle of view of a 50mm lens is 47° on the M9, but only 36° on the M8(.2). Note, however, that the focal length of the lens does not change when used on either camera.

PRAGUE IN FOCUS «
A 90mm lens is perfect for shooting architectural details such as the view of the Astrological Clock in Prague's city center.

A 50mm lens is invaluable »
for wider views of a city, like this statue on the Charles Bridge silhouetted against a morning sky.

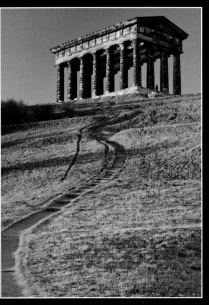

ONE POSITION, TWO PHOTOS ⌃

Without moving the camera, which was mounted on a tripod, I was able to create two images simply by using two lenses of different focal lengths. The photo on the left was shot with a 75mm lens; the photo on the right with a 35mm lens.

› Standard lenses

A "standard" or "normal" lens has a focal length that is roughly equal to the diagonal size of the imaging surface in the camera on which it is used. On a "35mm" or full-frame sensor, such as the one used in the M9, this equates to 43mm. This is a focal length that is rarely found in a manufacturer's lineup, the closest equivalent usually being 50mm. For that reason, the 50mm lens has become the "standard" lens by default.

The 50mm lens produces images that most closely resemble perspective as we perceive it. Because of this, it is often underrated as a lens. Images produced with a 50mm lens often don't have the visual impact of images taken with a wide-angle or long-focal-length lens.

However, they should not be dismissed so lightly. The 50mm is a perfect "walk-around" lens. It is reasonably light (not counting the weighty Noctilux), and the focal length allows an intimate photographic style without daunting your subjects the way a longer lens would. For these reasons, the 50mm was often the favorite lens of journalists during the first few decades after the Leica M-mount was introduced.

INTIMATE LANDSCAPE **«**
This shot takes advantage of the perspective of the 50mm lens. A wider-angle lens would have reduced the size of the distant mountains. A longer lens would have lost the lines in the foreground leading your eye up through the picture.

› Wide-angle lenses

As previously noted, a wide-angle lens is one that has a wide-angle of view. Visually, this means a greater sweep of a scene is included in the image than would occur with a standard lens.

This results in a greater amount of perspective distortion in comparison to a standard lens. This is seen most often with images of architectural subjects, when a slight tilt of the camera from the perpendicular can cause "converging verticals," where the subject appears to dramatically fall backward or lean forward.

The wider the lens, the more unnatural the perspective will look. Wide-angle lenses are not normally used for portraiture, since their perspective is less than flattering. Landscape photographers use wide-angle lenses to create a sense of open space or to isolate foreground subjects from the background.

Traditionally, 28mm was considered to be a wide-angle lens, and the basic M9 viewfinder does not support any lens wider than this. However, Leica and third-party lens manufacturers do produce wider-angle lenses that require the use of a supplementary viewfinder, which usually has to be fixed above the lens mount in the camera's flash hotshoe.

SUPER-ELMAR-M 18MM F/3.8 ASPH.
The widest Leica prime lens.

CONVERGING VERTICALS »
The dramatic effect often apparent when using a wide-angle lens to shoot up at architectural subjects.

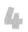

› Long lenses

The longest lens it is possible to use on the M9 and compose with the standard viewfinder bright lines is 135mm. Compared to SLR systems, this is still a comparatively short focal length. However, this does not mean that it is not a useful lens to own, and visually there are big differences between 135mm and a 50mm or wide-angle lens.

Long lenses magnify distant objects, allowing you to stay at a reasonable distance from your subject. Although 135mm is probably too short for successful nature photography, it is an ideal portrait lens. The perspective of a long lens is "flatter" than a wide-angle lens and is therefore more flattering to facial features.

It is more difficult to achieve front-to-back sharpness on a long lens, since it will have less inherent depth of field than a lens of shorter focal length. However, this limitation can be used to great effect by deliberately using wide-open apertures.

When a lens is used wide open, depth of field is at a minimum. Apart from the focus point, large areas of the scene may be out of focus. How visually attractive these out-of-focus areas are differs from lens model to lens model and depends on the number of aperture blades in the lens. The greater the number of blades, the more pleasing the quality of the out-of-focus areas. This aesthetic quality is known as "bokeh." Although all lenses can have out-of-focus areas, the effect is seen more often on longer lenses because of their inherently smaller depth of field.

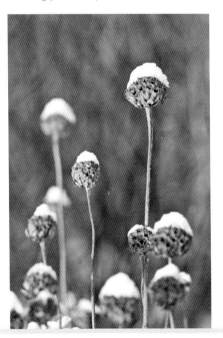

OUT OF FOCUS　　　　　　　　　　**«**
By shooting at f/4 on a 135mm lens, I was able to limit the zone of sharpness to a few of the seed heads. This helps to draw the eye to them, since you tend to disregard areas that are out of focus.

› Macro

One of the drawbacks of a viewfinder camera is that the closer the subject is to the camera, the more difficult it is to correct for parallax error. This makes it difficult, but not impossible, to produce macro images, since they require very precise framing.

Leica produces only one macro lens, the MACRO-ELMAR-M 90mm f/4. It can be used either on its own or with the optional Leica Macro-Adapter M *(see page 210).*

Because depth of field diminishes as the distance from the camera to the subject is reduced, achieving overall image sharpness can be problematic. The MACRO-ELMAR-M 90mm is one of the few Leica lenses that allows you to stop down to f/22 to maximize depth of field.

› Zoom lenses

A true zoom lens would be impractical on the M9, since the viewfinder would not be able to accommodate the bright line frames for the full range of possible focal lengths. However, Leica does produce a "zoom," the TRI-ELMAR-M 16-18-21mm. This lens comes with its own variable viewfinder, which mounts on the flash hotshoe of the M9.

There is no "in-between" when changing the focal length of the lens. However, unlike most zooms, this does mean that each focal length has its own depth-of-field scale marked on the lens.

TRI-ELMAR-M 16-18-21MM »
Leica's "zoom" for the M9.

4 » INCOMPATIBLE LENSES

Although the Leica M9 is compatible with most lenses designed for the M-mount system, there are several lenses that cannot be used. The lenses listed in the panel below should not be attached to the M9, since they will not operate.

Hologon 15mm f/8

Summicron 50mm f/2

(set to close-up)

Elmar 90mm f/4 with retractable tube

(manufactured between 1954 and 1968)

Examples of the Summilux-M 35mm f/1.4

(manufactured in Canada between 1961 and 95) Either cannot be fitted or will not focus to infinity. These lenses can be modified to work with the M9, however, by Leica Customer Services.

Any lens with a retractable tube should only be used with the tube extended.

(the current Macro-Elmar-M 90mm f/4, is the only exception to this warning) If the tube extends inside the sensor chamber, there is a real risk of damage to the camera.

The following lenses can be used safely with the M9, but TTL metering is not possible.

Exposure must be set manually using a reading from a handheld meter:

Super-Angulon-M 21mm f/4
Super-Angulon-M 21mm f/3.4
Elmarit-M 28mm f/2.8 with a serial number earlier than 2 314 921.

AT THE END OF THE DAY »

Some shots are scrupulously planned, others are the results of chance. This is one of those images. I was on my way back home through a forest when the setting sun broke through cloud. I quickly set up my camera using the background trees to hide the sun and so reduce the risk of flare. After a minute of shooting, the show was over and I continued on my way. The moral is that photographic opportunities can happen at any point.

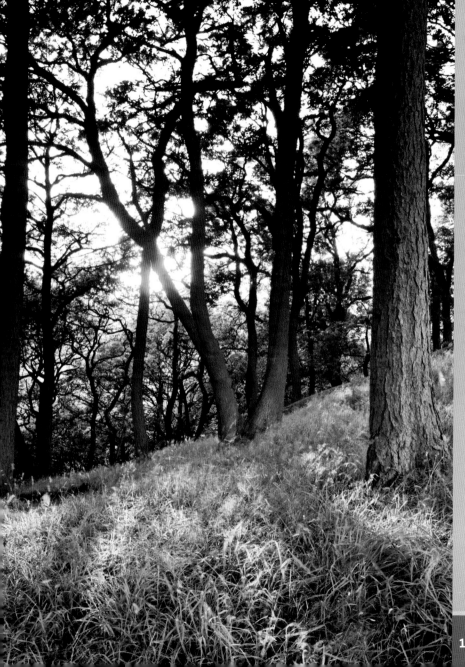

» CURRENT LEICA LENSES

Lens Name	Max./Min. Aperture	Focus Range (meters)
TRI-ELMAR-M 16-18-21mm f/4	f/4 / f/22	0.5m - ∞
SUPER-ELMAR-M 18mm f/3.8 ASPH	f/3.8 / f/16	0.7m - ∞
SUMMILUX-M 21mm f/1.4 ASPH	f/1.4 / f/16	0.7m - ∞
ELMARIT-M 21mm f/2.8 ASPH	f/2.8 / f/16	0.7m - ∞
SUMMILUX-M 24mm f/1.4 ASPH	f/1.4 / f/16	0.7m - ∞
ELMARIT-M 24mm f/2.8 ASPH	f/2.8 / f/16	0.7m - ∞
ELMAR-M 24mm f/3.8 ASPH	f/3.8 / f/16	0.7m - ∞
SUMMICRON-M 28mm f/2 ASPH	f/2 / f/16	0.7m - ∞
ELMARIT-M 28mm f/2.8 ASPH	f/2.8 / f/16	0.7m - ∞
SUMMILUX-M 35mm f/1.4 ASPH	f/1.4 / f/16	0.7m - ∞
SUMMICRON-M 35mm f/2 ASPH	f/2 / f/16	0.7m - ∞
SUMMARIT-M 35mm f/2.5	f/2.5 / f/16	0.8m -∞
NOCTILUX-M 50mm f/0.95 ASPH	f/0.95 / f/16	1m - ∞
SUMMILUX-M 50mm f/1.4 ASPH	f/1.4 / f/16	0.7m - ∞
SUMMICRON-M 50mm f/2	f/2 / f/16	0.7m - ∞
SUMMARIT-M 50mm f/2.5	f/2.5 / f/16	0.8m - ∞
APO-SUMMICRON-M 75mm f/2 ASPH	f/2 / f/16	0.7m - ∞
SUMMARIT-M 75mm f/2.5	f/2.5 / f/16	0.9m - ∞
APO-SUMMICRON-M 90mm f/2 ASPH	f/2 / f/16	1m - ∞
SUMMARIT-M 90mm f/2.5	f/2.5 / f/16	1m - ∞
APO-TELYT-M 135mm f/3.4 ASPH	f/3.4 / f/22	1.5m -∞
MACRO-ELMAR-M 90mm f/4	f/4 / f22	0.77m-∞

Angle of view (Diagonal)	Maximum magnification	Filter Thread Size (mm)	Dimensions (diam. x length; mm)	Weight (g)	6-Bit bar code
107°–92°	1:38–1:30	67	54 x 62 x 72	335	Yes
100°	1:34.6	77	61 x 58	310	Yes
92°	1:29	-	69.5 x 66	580	Yes
92°	1:29	55	58 x 46	300	No
84°	1:25	-	61 x 58.5	500	Yes
84°	1:26	55	58 x 45	290	No
84°	1:25.6	46	53 x 40.6	260	Yes
75°	1:22	46	53 x 40.8	270	No
75°	1:22	39	52 x 30	180	Yes
63°	1.17.4	46	56 x 46	320	Yes
63°	1.17.5	39	53 x 34.5	255	No
63°	1:20.4	39	51.4 x 33.9	220	Yes
47°	1:17	60	73 x 75.1	700	Yes
47°	1:11.3	46	53.5 x 52.5	335	No
47°	1:11.5	39	53 x 43.5	240	No
47°	1:14.1	39	51.5 x 33	230	Yes
32°	1:7	49	58 x 66.8	430	No
32°	1:9.9	46	55 x 60.5	345	Yes
22°	1:9	55	64 x 78	500	No
22°	1:8.9	46	55 x 66.5	360	Yes
18°	1:9	46	58.5 x 104.7	450	No
22°	1:6.7	39	52 x 59	240	No

Lens Name	Max./Min. Aperture	Focus Range (meters)
(V) 12mm f/5.6 UltraWide Heliar	f/5.6 / f/22	0.5m - ∞
(V) 15mm f/5.6 UltraWide Heliar	f/5.6 / f/22	0.5m - ∞
(CZ) 15mm Distagon T* 2.8 ZM	f/2.8 / f/22	0.3m - ∞
(CZ) 18mm Distagon T* 4 ZM	f/4 / f/22	0.5m - ∞
(V) 21mm f/4.0 Color Skopar Pancake II	f/4 / f/22	0.5m - ∞
(CZ) 21mm Biogon T* 2.8 ZM	f/2.8 / f/22	0.5m - ∞
(CZ) 21mm C Biogon T* 4.5 ZM	f/4.5 / f/22	0.5m - ∞
(CZ) 25mm Biogon T*2.8 ZM	f/2.8 / f/22	0.5m - ∞
(V) 28mm f/2 Ultron	f/2 / f/22	0.7m - ∞
(CZ) 28mm Biogon T*2.8 ZM	f/2.8 / f/22	0.5m - ∞
(V) 35mm f/1.2 Nokton	f/1.2 / f/22	0.7m - ∞
(V) 35mm f/1.4 Nokton	f/1.4 / f/22	0.7m - ∞
(V) 35 mm f/2.5 Color Skopar Classic	f/2.5 / f/22	0.7m - ∞
(CZ) 35mm Biogon T*2 ZM	f/2 / f/22	0.7m - ∞
(CZ) 35mm C Biogon T*2.8 ZM	f/2.8 / f/22	0.7m - ∞
(V) 40mm f/1.4 Nokton	f/1.4 / f/16	0.7m - ∞
(V) 50mm f/1.1 Nokton	f/1.1 / f/16	1m - ∞
(CZ) 50mm C Sonnar T* 1.5 ZM	f/1.5 / f/16	0.9m - ∞
(CZ) 50mm Planar T* 2 ZM	f/2 / f/22	0.7m - ∞
(V) 75mm f/1.8 Heliar	f/1.8 / f/16	0.9m - ∞
(CZ) 85mm Sonnar T* 2 ZM	f/2 / f/16	1m - ∞
(CZ) 85mm Tele-Tessar T* 4 ZM	f/4 / f/22	0.9m - ∞

Angle of view (Diagonal)	Maximum magnification	Filter Thread Size (mm)	Dimensions (diam. x length; mm)	Weight (g)	6-Bit bar code
121°	–	67	74.6 / 42.5	230	No
110°	–	52	59.4 / 38.2	156	No
110°	1:18	72	78 / 92	550	No
98°	1:23	58	65 / 71	350	No
91°	–	39	55 / 25.4	136	No
90°	1:21	46	53 / 75	280	No
90°	1:20	46	53 / 56	210	No
82°	1:18	46	53 / 71	260	No
75°	–	46	55 / 51.2	244	No
75°	1:16	46	53 / 62	230	No
63°	–	52	63 / 77.8	490	No
63°	–	43	55 / 28.5	200	No
63°	–	39	55 / 23	134	No
63°	1:18	43	52 / 68	240	No
63°	1:17	43	52 / 55	200	No
56°	–	43	55 / 29.7	175	No
46°	–	58	69.6 / 57.2	428	No
46°	1:15	46	56 / 63	250	No
46°	1:12	43	52 / 68	230	No
33°	–	52	57.9 / 73.8	427	No
29°	1:10	58	70 / 100	500	No
29°	1:9	43	54 / 95	310	No

Chapter 5
FLASH

5 FLASH

A photograph is created by light. When natural light is insufficient, illumination from a small, lightweight flashgun is the most common way to add extra light to a scene. The M9 does not have a built-in flash, but it is compatible with a wide range of third-party flashguns as well as those made by Leica.

It is the very portability of flashguns that is their weakness. Because they are small, they are not particularly powerful. However, this does not mean that they cannot be used in a creative manner. And when light levels are low, it is better to have some form of illumination than none at all.

› Guide Numbers

The maximum power output of a flashgun is measured as a numerical value. This value, known as the guide number (or GN), allows you to calculate the flashgun's range in either meters or feet. If the ISO on a camera is altered, the GN changes. The higher the ISO, the greater the range of the flashgun and therefore the larger the GN. To avoid confusion, ISO 100 is used by manufacturers as a standard value when quoting the GN of a flashgun.

The GN can be used to determine the aperture value needed to correctly expose a subject at a given distance, or calculate the effective range of the flashgun at a chosen aperture. The formula to calculate both is respectively:

GN/distance = aperture
GN/aperture = distance

Using the Leica SF 58 flashgun as an example (which, as the name suggests, has a GN of 58m/190.29ft), at an aperture setting of f/8 at ISO 100, the effective flash distance is 7.25m or 23.7ft (the M9 cannot be set to ISO 100, but at ISO 80 the difference is marginal).

When the ISO on the camera is doubled, the effective flash distance is multiplied 1.4 times. At ISO 200, and at an aperture of f8, the effective flash distance is 10.15m (33.3ft).

MEDIEVAL PELE TOWER »
Using a slow synchronization allows you to expose for the ambient-light background as well as the flash-lit foreground.

» FLASH BASICS

The fastest shutter speed you can use when shooting with flash is the synchronization speed. On the M9, the sync speed is 1/180. This is shown by the red ⚡ symbol on the shutter speed dial. If you use a faster shutter speed, the flashgun will not fire. Using a slower shutter speed will allow you to adjust the exposure for any part of the scene not illuminated by flashlight.

Using flash manually at full power, you adjust the lens aperture to control the flash exposure. If your subject is farther than the effective flash distance for the set aperture, the subject will be underexposed. If the subject is closer than the effective flash distance, you can either reduce the flash output using controls on the flashgun, or close the aperture further to reduce the effective flash distance.

Fitting a flashgun

The M9 has an in-built hotshoe to attach external flashguns. Leica produces two

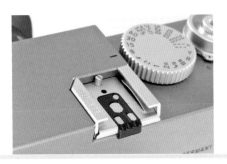

flashguns for the M9, although third-party flashguns that have a standard hotshoe fitting with a positive center contact, and which are fired by the center contact, are compatible with the camera.

1) Turn off both the M9 and the flashgun.

2) Slide the foot of the flashgun onto the hotshoe of the M9. Do not try to force the flashgun if resistance is high. Remove the flashgun and realign if necessary.

3) Once the flashgun is fully attached to the camera, tighten the clamping nut on the flashgun (if one is fitted).

4) Turn on the M9 and then the flashgun.

› Automated flash

If your flashgun is fully compatible with the M9, you can set flash output so that exposure is calculated automatically. This option is available in all modes, including Snapshot profile. Automated flash works by the M9 controlling the power of the flash output. As the ambient brightness of a scene increases, flash output is reduced up to 1 ⅔ of a stop. If the ambient brightness increases to a point that a shutter speed faster than flash sync speed is required, the flash will not fire. With a compatible

flashgun, the M9 also transfers the camera ISO information to the flashgun.

Setting automated flash

1) Fit the flashgun, and turn on both the flashgun and camera.

2) Set the flashgun to GNC (Guide Number Control) mode.

3) Set the desired shutter speed (one that does not exceed the sync speed).

4) Set the required aperture, one that is large enough so that the effective flash distance is equal to or greater than the subject distance (too small an aperture and your subject may not be illuminated correctly).

5) Lightly press down on the shutter-

release button to switch on the M9's exposure metering. If you press down on the shutter-release button missing out this step, the flashgun may not fire.

Notes:
When a compatible flashgun is attached to the M9, ⚡ will be displayed in the viewfinder.

In Snapshot profile, you cannot use any shutter speed other than the flash sync speed of 1/180. Other creative flash settings, such as being able to choose the curtain synchronization, are also unavailable.

Flash troubleshooting

If the ⚡ symbol does not appear in the viewfinder after the flashgun has been switched on and is charged ready for use: Check the shutter speed dial is not set faster than 1/180.

The ⚡ symbol flashes slowly in the viewfinder: The flashgun is still charging. Once the flashgun has charged, ⚡ will remain lit.

As the flashgun batteries run down, the time taken to recharge will increase.

The ⚡ disappears from the viewfinder after a flash exposure: Indicates potential underexposure of the image. Check the power output of the flash and also that your subject is within the effective flash distance for the aperture you have set.

› Flash exposure charts

The range of the flashgun fitted to the camera will depend on the ISO settings and aperture you've chosen. Use these charts to gauge the appropriate settings in different situations for two external flashguns produced by Leica.

Leica SF 24D

ISO	Aperture						
	F2.0	f/2.8	f/4	f/5.6	f/8	f/11	f/16
160	14.5m	10.35m	7.24m	5.18m	3.62m	2.64m	1.81m
	47.6ft	34ft	23.76ft	16.99ft	11.88ft	8.66ft	5.94ft
200	16.97m	12.12m	8.49m	6.06m	4.24m	3.09m	2.12m
	55.68ft	39.76ft	27.85ft	19.88ft	13.91ft	10.14ft	6.96ft
400	24m	17.14m	12m	8.57m	6m	4.36m	3m
	78.74ft	56.23ft	56.23ft	28.12ft	19.69ft	14.30ft	9.84ft
800	33.94m	24.24m	16.97m	12.12m	8.49m	6.17m	4.24m
	111.35ft	79.53ft	55.68ft	39.76ft	27.85ft	20.24ft	13.91ft
1600	48m	34.29m	24m	17.14m	12m	8.73m	6m
	157.48ft	112.50ft	78.74ft	56.23ft	39.37ft	28.64ft	19.69ft

Leica SF 58

ISO	Aperture						
	F2.0	f/2.8	f/4	f/5.6	f/8	f/11	f/16
160	35m	25m	17.05m	12.5m	8.73m	6.37m	4.38m
	114.83ft	82.02ft	55.94ft	41.01ft	28.64ft	20.90ft	14.37ft
200	41.01m	29.29m	20.51m	14.65m	10.25m	7.46m	5.13m
	134.55ft	96.10ft	67.29ft	48.06ft	33.63ft	24.48ft	16.83ft
400	58m	41.43m	29m	20.71m	14.5m	10.55m	7.25m
	190.29ft	135.93ft	95.14ft	67.95ft	47.57ft	34.61ft	23.79ft
800	82.02m	58.59m	41.01m	29.29m	20.51m	14.91m	10.25m
	269.09ft	192.22ft	134.55ft	96.10ft	67.29ft	48.92ft	33.63ft
1600	116m	82.86m	58m	41.43m	29m	21.09m	14.5m
	380.58ft	271.85ft	190.29ft	135.93ft	95.14ft	69.19ft	47.57ft

» FILL-IN FLASH

Attaching a flashgun to your Leica M9 allows you to use fill-in flash as a way of controlling contrast. This is particularly useful when your subject is backlit *(see page 110)*. Using fill-in flash to illuminate your subject can also help to avoid camera shake, since the shutter speed can be increased up to the maximum sync speed.

If the flash output is too strong, the subject will look overlit and no longer appear to be part of the background. Do not adjust the exposure on the camera, but alter the power output of your flashgun. How much adjustment you need to make will depend on how unlit your subject is in comparison to the background, but typically ½ to 1½ stops is a good starting point.

LIGHT TEMPERATURE **«**
Flash light is very close to daylight in terms of color temperature. To "warm" up the light, without affecting the background, fit yellow or red gels over the flash head.

» 1ST- AND 2ND-CURTAIN SYNCHRONIZATION

A focal-plane camera shutter has two light-tight curtains, one in front of the other. On older cameras these curtains are often made of cloth and so suffer problems with light leaks through wear and tear. Modern camera systems, such as the M9, use metal curtains that are rated for tens if not hundreds of thousands of shutter actuations.

When a camera shutter-release button is pressed, the 1st (or front) curtain rises exposing the film or sensor to light. After a period of time the 2nd (or rear) curtain also rises, blocking light from reaching the film or sensor once more. The period of time between the start of the rising of the two curtains is the shutter speed that the camera is set to.

LIGHTSHOW »
Using flash allowed me illuminate this VIP's face, which was in shadow from the gas burner behind his head.

The M9 allows you to set your flashgun to fire either when the 1st curtain rises (1st curtain synchronization) or when the 2nd follows (2nd curtain synchronization). If there is no movement in the scene there will be no discernible difference between the two settings. However, if your subject should move across the frame during exposure, the setting you choose will be very important.

With 1st curtain synchronization your subject will be "frozen" by flashlight at the start of the exposure. Any movement subsequent to this will be recorded as a blur in front of the subject. With 2nd curtain synchronization your subject will be "frozen" by flashlight at the end of the exposure. Any movement before this will be recorded as a blur behind the subject. Of the two, 2nd curtain synchronization usually looks more natural, though this is no reason why you should not experiment with the two settings.

Monitor brightness	Standard
Histogram	RGB
Folder managem.	LEICA
Auto review	Permanent
Auto power off	2 min.
Flash sync	1st curtain
Auto slow sync	2nd curtain

Setting flash curtain synchronization

1) In shooting mode press MENU to access the Main menu.

2) Highlight **Flash sync** and press SET.

3) On the submenu, highlight the desired option and press SET once more to save the setting and return the Main menu.

> **Note:**
> In Snapshot mode Flash Sync. is set to 1st curtain and can not be altered.

» SLOW SYNCHRONIZATION

A flashgun has a limited range and so although it may be able to illuminate your subject correctly, it may leave the rest of the scene underexposed. Slow synchronization gets around this limitation by allowing you to set the shutter speed so that ambient light can be used to expose the scene correctly.

Outside, slow synchronization is particularly effective at dusk when there is still sufficient ambient light that shutter speeds don't exceed the M9's 240-sec. limit. Once night has fallen and the sky is black, there may be little or no ambient light to light the scene.

As the light levels drop the shutter speed will invariably lengthen. To avoid the risk of camera shake you will need to support your M9 on a tripod. However, deliberately moving your camera during exposure can lead to interesting visual effects. Anything lit by the flash will be pin-sharp, everything else in the image will be rendered as a streaked blur. The longer the shutter speed, the more pronounced the effect.

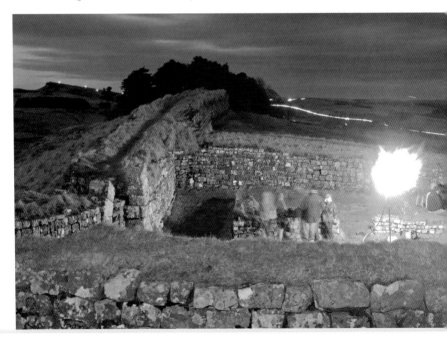

Selecting the Sync Speed/Sync Speed Range

In aperture priority the shutter speed is automatically selected for you. By default, if a flashgun is fitted and active, the M9 will choose the flash sync speed of 1/180. However, if the exposure for the background requires a longer shutter speed, the result will be underexposure of the non-flash lit areas. There are five settings for how the sync speed alters on the **Auto slow sync** Main menu option.

1) Press MENU and highlight **Auto slow sync**.

2) Press SET to view the submenu.

3) Highlight **Lens dependent** if you want the M9 to alter the shutter speed depending on the focal length of the attached lens. To avoid camera shake, the longer the lens, the shorter the shutter speed will be.

4) Highlight **Off (1/180s)** so that the M9 defaults to the sync speed of 1/180.

Histogram	RGB
Folder managem.	LEICA
Auto review	**Lens dependent**
Auto power off	Off (1/180s)
Flash sync	Down to 1/30s
Auto slow sync	Down to 1/8s
Color managem.	Down to 32s

5) Highlight **Down to 1/30s, Down to 1/8s,** or **Down to 32s** to select the longest shutter speed the M9 will choose depending on the ambient lighting conditions.

6) Press SET again to choose the highlighted option and return to the main menu. Press MENU to return to the main menu screen without altering the original setting.

7) Press lightly down on the shutter-release button to go directly to shooting mode. Press PLAY to go directly to image review. Press MENU to exit the menu system.

BULB SETTING «
Without flash the foreground wall in this image was underexposed. Using Bulb to correctly expose the interior of the shelter, I used flash to throw light into the foreground shadows. Anyone who moved during the exposure has been recorded as an indistinct blur.

Note:
Lens dependent requires a lens with 6-bit coding.

5 » BOUNCE FLASH

Flash light, when directed straight from a camera hotshoe, illuminates your subject frontally *(see page 110)*. As discussed previously, this is not the most flattering of lights. It is also a very hard, intense light that can cast deep shadows. One way to soften and redirect flash light is to reflect or bounce the light from another surface before it illuminates your subject. For this technique to work you will need a flashgun that has a tilt and swivel head. Of the two Leica flashguns, only the SF 58 has this specification.

The most common surface to bounce flash light from is a ceiling. Reflecting the light this way makes it a larger, and therefore, softer light source. However, the higher the ceiling, the greater the flash-to-subject distance will be. You will need to calculate this distance to ensure that the flash output, selected aperture or ISO is set to take account of this. Another caveat is to look at the color of the surface you want to bounce light off before you begin. Try to use as neutrally colored a surface as possible to avoid unwelcome color casts affecting your final image.

» DIFFUSERS & REFLECTORS

A flash diffuser is a translucent surface that attaches to the flash head. Flash light is a very direct light source. Diffusers soften flash light by scattering the light a touch more randomly. Although they do not stop flash from lighting your subject frontally, they will reduce ugly shadow areas at the cost of a slight reduction in the power output of your flash.

A reflector also fits onto your flash head. In essence it works in a similar way to using bounce flash described above, without the need for a handy ceiling or wall. Some of the flash output is soaked up by the reflector's surface, but the flash-to-subject distance is far less than if a wall or ceiling were used.

BOUNCING FLASH LIGHT ⌃
The photo on the left was shot at ¼ power with direct flash. The photo on the right was shot at full power but with a reflector fitted to the flash head, giving the bust a softer more expressive illumination.

OFF-CAMERA FLASH

A flashgun does not need to be fitted directly on the camera, or indeed attached to the camera at all, to be used creatively. Using a flash extension cable will enable you to move your flash off-center for a greater range of lighting options. Alternatively, using a wireless system such as those produced by PocketWizard will enable you to move your flash even farther from your camera. However, remember you will need to correct for the greater flash-subject-camera distance the farther the flash is from the camera.

When ambient light is low and shutter speeds are measured in tens of seconds you can use your flashgun to "paint with light." This can be hit and miss and it pays to experiment—but when it works it produces a unique effect.

To try this technique you will need a flashgun with a test-firing button and a fresh set of batteries. Mount your camera on a tripod and keep the flashgun in your hand. Use the longest shutter speed you can without causing overexposure (when it's really dark use B mode with a cable release or T mode to lock open the shutter on the camera). Trying not to disturb the camera, fire the flashgun several times at your subject, from different angles, during the exposure. When the exposure is finished, review the image and repeat if necessary.

CAPSTAN IN PROFILE «
Apart from ambient light there was nothing illuminating this capstan at the historic docks in Belfast, Northern Ireland. I used a flash off-camera to illuminate the area around the capstan during an exposure of 15 sec.

› Optional Flashguns: Leica SF 24D

The SF 24D is Leica's smallest and lightest flashgun and therefore has fewer features than the SF 58 on the page opposite. This does not mean that it is not a capable piece of equipment. The TTL exposure function is accurate, but can be overridden for complete control if required, with an exposure compensation of up to +/- 3 stops. The inclusion of two diffusion screens allows the SF 24D unit to be used with lenses between 24 and 85mm in focal length.

Guide number (GN):
24m/78ft (ISO 100)

Tilt/swivel:
No

Color Temperature:
5600K

Flash Modes:
TTL/Auto

Other Functions:
Exposure correction (+/-3 EV)

Illumination Profiles:
N/A

Second-curtain Flash Sync:
N/A

Approximate Recycling Time:
0.1 to 5 sec.

Batteries:
2 x CR123A

Dimensions (w x h x d):
2.6 x 4.3 x 1.6in (66 x 109 x 41mm)

Weight:
6.4oz (180g) without batteries

Included Accessories:
Manual/Soft pouch/85mm Tele Diffuser/0.9–1.1in (24–28mm) Wide Angle Diffuser

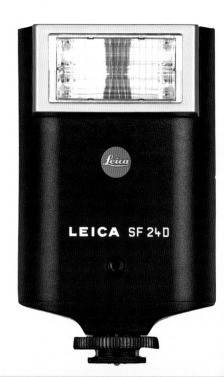

› Optional Flashguns: Leica SF 58

The SF 58 is Leica's flagship flashgun. It is compatible with cameras in the M range (from the M6 onwards) as well as the state-of-the-art S2 medium-format digital SLR. To make the SF 58 future-proof it sports an integrated USB port to allow firmware updates as needed. With compatible lenses, the flashgun can use the focal length information to optimize the flash output for each lens.

Guide number (GN):
58m/190ft (ISO 100)

Tilt/swivel:
vertical (-7°/+90°) / horizontal (-180°/+120°)

Color Temperature:
5600K

Flash Modes:
TTL/Auto/Manual/Stroboscopic

Other Functions:
Test light/AF assist light/Auto fill-in/ Manual flash exposure correction (+/-3 EV in 1/3 EV-steps)/HSS high speed synchronization

Illumination Profiles:
Standard/Soft

Second-curtain Flash Sync:
Yes

Approximate Recycling Time:
0.1–5 sec.

Batteries:
4 x AA

Dimensions (w x h x d):
2.8 x 5.82 x 3.9in (71 x 148 x 99mm)

Weight:
12.52oz (355g) without batteries

Included Accessories:
Manual/Belt Bag/Pedestal/4 x AA batteries

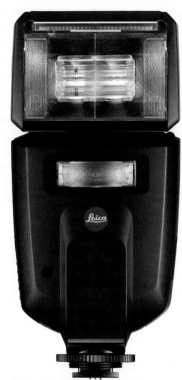

Chapter 6
LIGHTROOM

6 LIGHTROOM

Leica do not produce image-editing software of their own with which to adjust your M9 images. If you are shooting JPEG this is not too restrictive, since there are numerous options, from simple to sophisticated, that will allow you to adjust your images. However, if you are shooting RAW you need a specialist converter. Fortunately ownership of an M9 allows you to download the latest version of Adobe Lightroom, a well-regarded RAW converter that can do so much more.

Adobe Lightroom uses the technology that underpins Adobe Photoshop, but unlike Photoshop it is aimed primarily at photographers. Lightroom will help to import your images, allow you to add keywords, make tonal and lens correction adjustments, and then either export the images to another format or prepare your images for printing, or to be shown in a slideshow.

Lightroom is, therefore, a complex package. Unfortunately, this book does not have the space to cover everything that Lightroom has to offer. This chapter is a short guide to the software and some of the more useful tools that are available. As with most aspects of photography, the key to successfully using Lightroom is practise and experimentation. Only then will you be able to judge for yourself what approach suits you and your style of working.

LIGHTROOM **«**
The Develop module.

› The Lightroom philosophy

When working with most image-editing software, once an image has been altered it is almost impossible to undo the alteration at a later date. Lightroom differs in that the original RAW files are not overwritten as you make adjustments. Instead Lightroom builds up a "recipe" of adjustments as you make them. These adjustments are stored in a database of images, known as a Catalog, which Lightroom opens and displays each time the software is used. This means that it is possible to revisit and reinterpret your RAW files over and over again without any loss of quality.

› Working in Lightroom

Lightroom is split into five modules: Library, Develop, Slideshow, Print, and Web. Each of these modules allows you to work on your images in different ways. To work in a particular module, click on its name in the top right corner of the Lightroom page. Of the five modules, four (excluding Web) are described in this book.

Along the bottom of the screen is a filmstrip that shows you the range of images that are available to work on. The number of images that are shown will depend on how many images are in your catalog and whether you've filtered out a selection using the rating tools or added images to a collection. Clicking on an image in the filmstrip will allow you to edit that image in a number of ways depending on the module you are currently using.

LIGHTROOM «
The Library module.

On the right of the Lightroom screen are the option panels. These show the tools available in each module. On the left of the Lightroom screen are panels that allow you to sort your photos into collections (Library), view the history of alterations to an image (Develop), or apply Lightroom templates and presets. Clicking on the triangle in the top right corner of an option panel will hide or restore that particular panel to view.

Around the edges of the Lightroom screen are more triangles. Clicking on these hides elements of Lightroom, allowing you more space to view images. Clicking on the triangles again restores hidden elements, while moving your mouse pointer to the edge of the screen restores them temporarily.

Tips

Lightroom's Identity Plate in the top left corner of the screen can be customized for every catalog to help identification or to personalize the software. In Windows go to Edit > Identity Plate Setup. On a Mac go to Lightroom > Identity Plate Setup.

You can use a line of text to identify your catalog, or import a logo. The Identity Plate can then be overlaid on your slideshows (see page 198) or when creating a print (see page 202).

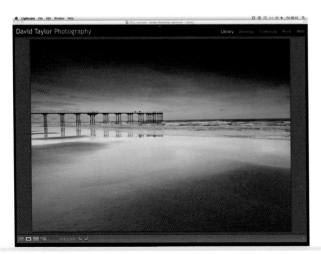

PANELS OFF 《
Pressing the tab button is a quick way to toggle the option panels on and off.

› Creating a catalog

To begin working with Lightroom you must first create a catalog. This is the database that your images will be imported into. You can create multiple catalogs so all your images do not need to be kept together, although creating a logical way of working at the start is important to avoid later confusion.

To create a catalog, go to **File > New Catalog**. You will be asked to create a folder for the database. This is not necessarily where your RAW files will be imported to, but does need to be on a drive with plenty of storage space for the Lightroom catalog database file. Once you've created your first catalog the next step is to import images files.

› Importing image files

Connect your camera or memory card to your PC *(see page 69)*. Lightroom will automatically detect that they have been added and display the import dialog box. You can either import the images to a new location, which is the recommended option, or let Lightroom reference the files in their current location. Once the files have been imported they can then be edited.

EDITING THE IDENTITY »
PLATE IN LIGHTROOM

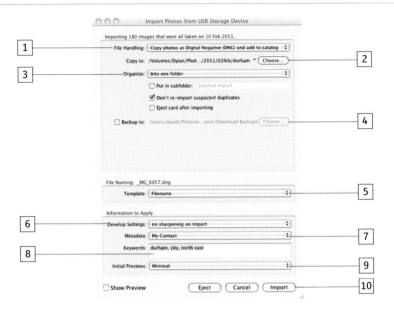

1) Menu to configure how Lightroom handles the imported images.

2) Where the images will be copied to. Click on **Choose** to navigate to a new folder.

3) Lightroom can copy the images into one folder or create new folders and divide the images up according to capture date.

4) Once the images have been imported they can be copied to a backup drive if required.

5) You can specify whether the files are renamed on import and how the renaming is achieved.

6) Develop Settings can be applied to all the images as they are imported.

7) Metadata, such as copyright information, can be edited in Lightroom and applied to images during the import process.

8) Different keywords can be added to your images, both during import and later when using the Library module.

9) Chooses the quality of the image thumbnails used in the module displays.

10) Eject the memory card/camera and either cancel or start the import by clicking on the relevant button.

THE LIBRARY MODULE

Once you've completed the import process, the images (and others in your catalog) are initially viewed in the Library module. These images can be viewed a number of different ways and sorted according to certain criteria. These criteria include a star rating system, the folders where images are stored, and a colored labeling facility.

Library is where you apply keywords and other metadata to your images that can be used by digital asset management software and online applications. You can also create "Collections" that enable you to easily keep track of photographic projects as they grow in size.

1) Navigator Shows the current image and allows you to set the zoom factor for the image thumbnail view.

2) Catalog Displays the number of images in the catalog, the number of images added to a collection, and the number of images added to the catalog at the last import.

3) Collections Images can be added to a Collection, allowing you to group images based on different criteria. To create a Collection click on the + symbol and follow the instructions in the subsequent dialog boxes.

4) Image views Images can be viewed in a number of different ways. Click on the view buttons to change the way images are displayed. From left to right: Grid (images are shown as a series of thumbnails); Loupe (the currently selected image only is displayed); Compare (two selected images are shown side by side); Survey (previews two or more images as tiled thumbnails).

5) Import/Export Import new images into the catalog or export the current selected image(s).

6) Filmstrip Shows the current selection of images. By default it will show all the images in your catalog. However, you can narrow the selection by creating a Collection.

7) Library Option Panels The main image option tools in the Library module.

8) Sync Settings/Sync Metadata Synchronize Develop settings between different images or synchronize metadata such as keywords or copyright details.

» THE LIBRARY OPTION PANELS

› Histogram

Shows the histogram of the current image
and the exposure data of the image stored
in metadata.

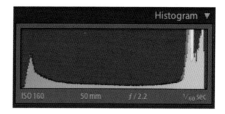

› Quick Develop

This panel allows you to make basic tonal
adjustments to your images without
recourse to the Develop module.

Saved Preset
Apply a Lightroom develop preset using
the drop-down menus, or your own
custom settings if previously saved.

White Balance
Quickly adjust the white balance of your
image by selecting a WB preset or using
the **Temperature** and **Tint** buttons to alter
the color temperature.

Tone Control
Selecting **Auto Tone** will let Lightroom
automatically adjust your image. To
manually adjust your image, use the
buttons to alter individual tone settings.
 Reset All restores your image back to its
original state at import.

› Keywording

The keywords that you apply to your images here will be embedded in the file metadata when you export the image. To add a keyword, click in the keyword box and type. Use either a comma or semicolon to separate your keywords. Once you've finished press the enter key.

If you've added keywords to images before, Lightroom will suggest these keywords if they seem relevant to the image you are currently keywording. If a word in Keyword Suggestions is relevant, click on it and it will be added to the keyword list.

Keywords can be added to Keyword Sets; these are keywords grouped under a common theme. You can use the sets provided by Lightroom or create your own.

Keyword List

Every keyword you add to images in your catalog is stored in the Keyword List. You can use the list to quickly see how many images in your catalog use particular keywords. Type the whole or part of a keyword into the **Filter Keywords** to narrow the number of keywords displayed in the list.

› Metadata

There are two kinds of metadata. The first are those created by the camera at the time of image exposure to record the camera settings (known as EXIF data). The second are sets of information that you can decide on and apply to your image files (known as ITPC data).

Which of the ITPC data fields you choose to edit is a personal decision, though the more information you add to your images the easier it will be to search for individual images in digital asset management software or online.

The data fields you can edit are shown as darker gray boxes in the Metadata panel. A good example is the Caption field. This should be used to describe your image in a comprehensive yet concise manner.

6 » THE DEVELOP MODULE

The Develop module is the "heart" of Lightroom, where you adjust the look of your images. This ranges from the most basic of white balance alterations to more sophisticated lens correction adjustments. Because you never alter the basic RAW file, Develop should be seen as a laboratory in which you can conduct experiments on your images. No matter what changes you make, you can undo these changes at any point. Once you are happy with your image it can be exported for use in documents or online.

1) Navigator Shows the current image and allows you to set the zoom factor for the image editor view.

2) Presets Adobe supplies a number of presets that can be applied to your images, or you can save your own and apply them to other images.

3) Snapshot This allows you to save a particular point in the image editing history that you can quickly return to.

4) History As you edit your image you build up a history of the adjustments that were applied to the image. History allows you to step back through these adjustments to the point at which the image was originally imported.

5 & 12) Rating Stars and Labels Apply stars or colored labels to your images. Images can then be sorted according to how these are applied, enabling you to quickly group

images of a particular type together.

6) Before/After The image editing view can be split so that you can view and compare the image with and without adjustments applied.

7 & 8) Copy & Paste Copy the settings that have been applied to one image and **Paste** them to another.

9) Filmstrip Shows the current selection of images. By default it will show all the images in your catalog. However, you can narrow the selection by creating a Collection.

10) Develop Option Panels The main image editing tools in the Develop module.

11) Image Editing View Shows the current image being edited, and a before-and-after comparison if selected.

13) Image Zoom Move the slider to zoom in and out of your image.

› Before/After

Before/After allows you to split the image editor view screen into two panes to see a "before" and "after" version of your current image. The Before pane shows the image as it was when first imported (including any presets applied during the import process). The After pane shows your image with all the adjustments applied. If you zoom in or out, or pan around the image in either pane, the other pane will synchronize the view. Click on the Before/After button and select one of the four

options described below. To return to single-view, click the single-view button to the left of Before/After.

Before/After Left/Right
The two views are shown side by side.

Before/After Left/Right Split
The image is split down the middle, one half showing "before," the other "after."

Before/After Top/Bottom
The two views are shown one on top of the other.

Before/After Top/Bottom Split
The image is split across the middle, one half showing "before," the other "after."

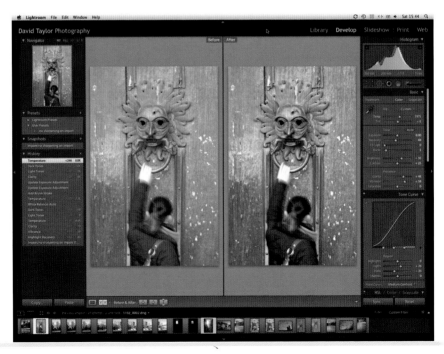

» THE DEVELOP OPTIONS PANELS

› Histogram

This shows you the histogram of the
image. As you make tonal adjustments the
histogram will alter to show you how the
tonal range of the image has changed.
Click on the triangle at the top left corner
of the histogram and any shadow detail
that is being clipped will be displayed in
blue in the main image to the left. Click
on the triangle at the top right and clipped
highlight detail will be shown in red. Drag
the histogram left or right to make quick
tonal changes.

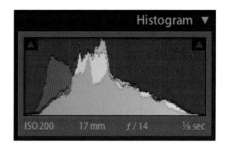

› Tool Strip

Most of the adjustments you make in the
Develop module are global. However, the
tools in the tool strip allow you to make
tonal adjustments to specific areas of an
image as well as to crop as required. *See
page 192* for more details.

› Basic

Color/Grayscale
Color by default, click on Grayscale to
remove the color from your image and
work in black & white.

› White Balance (WB)

The white balance setting will use the setting set by your M9 at the moment of image capture. Use the Temp slider to cool the image down by pulling it to the left, or warm up the image by pulling it to the right. Use the Tint slider to adjust for any green or magenta cast in your image. Click on the white balance preset menu to select one setting from a range of presets. Use the picker to select a color in the image as a basis for the white balance setting.

Tone Click on Auto to let Lightroom calculate the correct tonal range of your image.

Use the various sliders to adjust the tonal range of your image manually. If your image highlights are slightly clipped it is possible to recover some detail by using the Recovery slider. Fill Light lightens the shadow tones. Note that overuse of either option can cause unexpected tonal shifts.

Presence Clarity adjusts local contrast, making your image appear sharper. However, apply the setting too heavily and halos will appear around the elements of your image. Vibrance and Saturation adjust the vividness of the colors in your image.

› Tone Curve

The tone curve allows you to make adjustments to the tonal range of the image. Halfway across the diagonal line are the mid-tones. Click on the line at this point and pull up and the mid-tones will be lightened. Click and pull down and they will be darkened. Click higher up the curve and you can adjust the highlights in a similar way; click lower down to adjust the shadows.

The sliders below allow you to adjust the tonal range very precisely. As you change the sliders, the curve changes shape to show the adjustments you've made.

› HSL/Color/Grayscale

This option panel allows you to adjust specific colors, from red through to magenta, in your image. Pull the sliders to the right to increase the effect, the left to decrease the effect.

Hue alters a color by swapping it for another. You could, for example, turn everything in your image that is yellow to blue.

Saturation alters the vividness of a particular color.

Luminance alters the brightness level of a color.

All Expands the option panel to show all three options above at the same time.

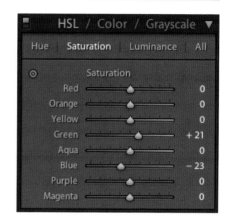

› Split Toning

If you are working in grayscale, spilt toning allows you to alter the color tint of the highlights and shadows of your image. The two tints can be different, and often you may find that warm highlights and cool shadows work well together.

Detail

These options alter specific types of detail in an image.

Thumbnail Shows the effects of your alterations in detail. Move the thumbnail around by dragging with the left mouse button.

Sharpening Sharpening increases the micro-contrast in an image. Some sharpening is required for printing or for images used on-screen, but apply too much and ugly halos will be apparent around the elements of your image.

Noise Reduction Reduces the amount of noise in an image caused by the use of high ISO.

Chromatic Aberration Adjust for two types of chromatic aberration—Red/Cyan or Blue/Yellow *(see page 126)*—with **Defringe:** select **All edges** from the drop-down menu to correct for color fringing on the edges of elements in your image. If this results in thin gray lines in your image, select either **Highlight Edges** or **Off** to turn off defringing entirely.

> ## Vignettes

Using lenses at their widest aperture can cause light fall-off at the edges of the image. Adding a positive value to the **Amount** slider under **Lens Correction** allows you to correct for this. With a negative value you can add darkened corners rather than remove them. This is particularly effective with black-and-white photography, helping to emphasize the center of your image. **Midpoint** allows you to increase or decrease the size of the area that is altered. **Lens Correction**

affects the entire image *(see page 192)*. If you've cropped your image and only want to affect the cropped area use **Post-Crop correction**. **Roundness** alters the circularity of the vignette, **Feather** adjusts the softness.

› Camera Calibration

With this option you can adjust how the colors from your M9 are interpreted by Lightroom. Select the **Profile** you wish to use from the drop-down menu. **Embedded** is the standard M9 color profile, though Lightroom also allows you to choose **Adobe Standard**, which improves the rendering of warmer colors such as red and yellow.

The color sliders allow you to adjust the color tint of the shadows in your image as well as the hue and saturation of the red, green, and blue components.

Previous, Sync, and Reset

Click on **Previous** if you want to apply the settings from the previous image to the current one. If you have multiple images selected in the filmstrip **Sync** replaces **Previous**. Clicking on **Sync** will bring up a dialog box that allows you to apply all or some of the same settings that have been applied to your primary

image. **Reset** returns the image to its original settings at import. This step is added to the history so you can step back to undo if necessary.

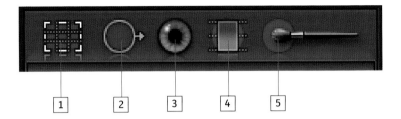

| 1 | 2 | 3 | 4 | 5 |

The Tool Strip allows you to apply local adjustments to areas of your images. When you click on one of the tools, the options for that tool will be displayed below the strip.

1) Crop

When **Crop** is selected, a frame is drawn around your image. The parts of the image that are outside the frame will be cropped. Pulling the frame inwards by the edges will shrink it, increasing the area that will be cropped; pulling it outwards will reduce the area that will be cropped.

With **Aspect** set to **Original** the frame changes size to match the aspect ratio of the image. Clicking on the drop-down menu displays a range of options for commonly used aspect ratios such 1:1 or 4:5. Click on the padlock icon to "unlock" it and the frame size can be changed horizontally or vertically without the other direction altering.

The **Angle** slider allows you to rotate your image freely, cropping as necessary to maintain a rectangular image. Clicking on the "spirit-level" icon is a freehand way of achieving an image rotation. With the spirit-level selected, left click and drag within your image. The image will be rotated at the angle created by the start and end position of your mouse click.

2) Spot Removal

Invariably there will be spots and blemishes in your image. The spot removal tool is designed to simplify the task of removing these blemishes. The tool works by using two connected circles: the first circle indicates the area that needs repairing, the second is the part of your image which is sampled to "patch" the repair.

Clone replicates the sampled area exactly. **Heal** attempts to match the texture, tone, and shading to improve the repair process.

With the tool selected, click on the area you wish to repair and then, with the mouse button held down, drag to an area of similar color or detail. Release the mouse button to make the repair.

The size of the circle can be altered by changing the **Size** slider. You can also resize the spot removal tool once it has been applied by selecting the "repair" circle and then dragging it in and out to decrease and increase its size respectively.

You can also move the second circle retrospectively by clicking on it and dragging it to a new location.

The **Opacity** slider alters the transparency of the spot removal. At 100 the tool is completely opaque, at 0 it is completely transparent. To delete an applied spot removal tool, select it and then press backspace or delete.

3) Red Eye Correction

When using flash on-camera for portraiture your subjects can often suffer from "red-eye." This is caused by the flashlight bouncing off the back of the eye and out through the iris again. Red Eye Correction is used to reduce or remove this effect.

With the red-eye tool selected, click on the center of the eye you want to correct and drag outwards to change the tool size.

Change **Pupil Size** by dragging the slider left or right to decrease or increase the selection respectively. Use the **Darken** slider to darken the pupil within the selection and the area of the selection outside. Don't forget to apply the same to the other eye!

4) Graduated Filter tool

This tool can be used in a similar way to a ND-Graduate filter *(see page 218)* to darken areas of an image that are too bright in comparison to others. However, it's capable of much more than that and is one of the most useful tools in Lightroom.

To use the tool, select which aspect of your image you want to adjust and then use the slider to alter the level of adjustment.

Exposure Alters the image brightness, mainly affecting the lighter tones.

Brightness Alters the image brightness, mainly affecting the mid-tones.

Contrast Alters the image contrast, mainly affecting the mid-tones.

Saturation Alters the vividness of the colors in the image.

Clarity Adds or removes depth to/from an image by adjusting local contrast.

Sharpness Increases or decreases edge definition to adjust the apparent detail of your image.

Color Applies a color wash to an area. Click on the color picker box on the right to select a color.

Now move your mouse pointer over the image. Click and drag to apply the graduated filter; the farther you drag the more subtle and attenuated the filter effect will be. The center of the effect is shown by the graduated filter "pin" (1, below). The three guidelines above, through, and below the pin, show the start (2), mid-point (3) and end (4) of the effect. After the effect has been applied you can adjust the size of the range by clicking on the guidelines and pulling them closer or farther apart.

To rotate the effect, move your pointer over the pin until it turns into a two-headed arrow. Hold down the left mouse button and move the mouse left or right until the filter is in the desired orientation.

To move the filter around your image, place your pointer over the pin until it turns into a hand. Then hold down the left

mouse button and drag to move.

To delete an applied graduated filter, select it then press backspace or delete.

5) Adjustment Brush

The adjustment brush works in a similar way to the graduated filter tool allowing you to alter selected areas of your image. Where it differs is that you can very precisely paint these effects wherever they are needed.

As with the graduated filter first select the effect you want to apply to your image.

Next, alter the **Brush** sliders below to suit your requirements.

Size Alters the size of the brush in pixels.

Feather Alters the softness of the brush, which determines how quickly the effect fades away from where the brush is applied.

GRADUATED «
FILTER TOOL
Using the Graduated Filter tool Exposure option to darken the sky of a landscape image.

Flow Controls how fast the effect is applied as you paint.

Auto Mask Confines the brush strokes you make to pixels of a similar color.

Density Controls the transparency of the brush.

Now move your mouse pointer over the image. Click to place a single adjustment brush spot, or click and drag to paint a larger area.

Once you've finished, a "pin" will show you the place that the effect was applied. With the pin selected you can adjust the sliders to alter the level of application of the effect. Alternatively, move your pointer over the pin until it turns into a two-headed arrow. Hold down the left mouse button and move the mouse left or right to increase or decrease the level of application.

To remove part of the adjustment click on **Erase** in the Adjustment Brush tool drawer, and paint over the area you've adjusted. The brush will be shown with a minus symbol (-) at the center.

To delete an applied adjustment brush, select it and then press backspace or delete.

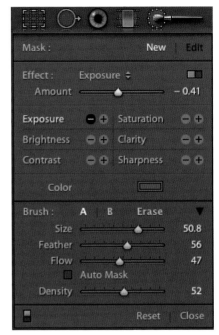

› Exporting an Image

Once you've finished editing an image it will need to be exported to a different file format if you wish to use for it other purposes. Select the files you wish to export then select **File > Export**, or right click on a file and select **Export** from the options menu. Selecting **Export Previous** will export your file(s) using the previous settings. Select the required options from the Export dialog box and click **Export**.

1) Choose whether to export to a new folder or to the same folder as the RAW file.

2) Select the new destination folder using the **Choose** button.

3) Create a subfolder if required.

4) Choose how Lightroom deals with existing files with the same name.

5) File names can be altered on export: use this drop-down menu to choose how.

6) Select the file format type and compression level if relevant. Lightroom can export images in five different formats:

PSD (Adobe Photoshop's native format); TIFF; JPEG; DNG or Original RAW format, though as the M9 uses DNG this is largely redundant).

7) Set the size of the file if you want to reduce or expand the resolution and choose the required pixels per inch/centimeter.

8) Apply sharpening to the image if required.

9) Apply user-defined metadata to the exported image(s)

10) Select what happens to the image after exporting; eg, the exported image(s) can be opened in Photoshop immediately.

» SLIDESHOW MODULE

The Slideshow module allows you to set up a variety of sophisticated and professional-looking slideshows quickly and easily. A variety of effects can be applied to your images, including drop-shadows and borders. You can also add text. The text can either be written by you and be as descriptive as you like, or provide technical information from the image metadata such as exposure or equipment details. To give your presentation that final polish you can also link Lightroom to your music library. All you need to do then is find friends and family to enjoy the show.

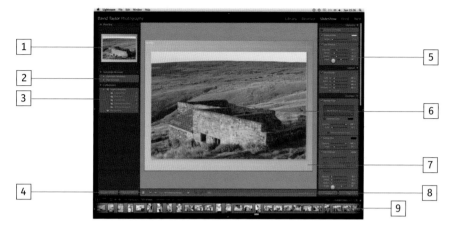

1) Template preview The thumbnail in template preview shows how your image will be displayed during the slideshow presentation.

2) Slideshow template options Adobe supplies a number of templates that can be applied to your slideshows, or you can save your own and apply them to future presentations.

3) Collections list Collections of images set up by you in the Library module.

4) Slideshow playback controls Play, pause and stop the slideshow. Select which photos are to be included in the slideshow.

5) Slideshow option panels Choose how your slideshow will look, the duration of the show and whether any accompanying music will be played. Check the tick box in the top left corner of the individual option panels to apply the option to the slideshow.

6) Slide editor view This is the slideshow view, including the frame guides. Any additions to the slideshow, such as text, can be placed and positioned here.

7) Frame guides The frame guides allow you to resize your images within the slideshow screen. Pulling the frame guides outwards increases the size of the images; pushing them inwards decreases the size. Altering the frame guides for one image alters them for all the images.

8) Text tools You can add text to your slideshows by clicking on the text tool button. The default choice is a line of custom text, but you can also choose from a variety of options, such as exposure details, by using the drop-down menu.

9) Filmstrip Shows the current selection of images. By default it will show all the images in your catalog. However, you can narrow the selection by creating a Collection.

Options

Zoom Fill Frame Click to force your images to fill the area delineated by the frame lines. If the aspect ratio of the frame guides is different to your images, the images will be stretched to fit.

Stroke Border Adds a line around the edge of your images. The slider changes the width of the line. Click on the color picker rectangle to choose the color of the line.

Cast Shadow Choose whether your images have a shadow to help them stand out from the background. This is particularly effective if you use a light background, less so with a dark. **Opacity** alters the transparency of the shadow. **Offset** adjusts how far the shadow moves from the images: a longer offset will make your images seem higher up from the background. **Radius** changes the softness of the shadow. Finally, **Angle** changes the direction from which the shadow is cast.

Layout

Show Guides Move the position of the show guides in pixel increments using this option. Guides can be moved individually, or with **Link All** checked, as a group.

Overlays

Identity Plate With this overlay selected your name can be added to the slideshow.

Use **Opacity** and **Scale** to alter the transparency and size of the text respectively to suit.

Rating Stars If you've applied rating stars to your images, they will be displayed during the slideshow by selecting this option. Use **Opacity** and **Scale** to alter the transparency and size of the stars respectively to suit.

Text Overlays Custom text can be added to your slideshows. Once you've added text use this option to control the **Opacity**, and the font and justification you require.

Shadow Once you've created your custom text use this option to create a drop shadow to help the text stand out from the background. As with **Cast Shadow**, the sliders control the transparency, distance, softness, and direction that the shadows fall from.

Backdrop

Color Wash This option adds a color gradient over your slideshow background. Use **Opacity** to select how strongly the color wash is applied and **Angle** to change the direction the gradient flows from. Click on the color picker rectangle to choose the color of the gradient.

Background Image You can use any of the images in the filmstrip at the bottom of the screen as a background for the slideshow. Simply click and drag an image to the box in the Background Image panel.

Titles

Intro Screen Begin your slideshow with an introduction screen. This can be your identity plate details or a plain overall color.

Ending Screen End your slideshow with an ending screen. This can be your identity plate details or a plain overall color.

Playback

Soundtrack and **Slide Duration** If you have iTunes or a similar application installed, you can use music from your catalog to accompany your slideshow. **Slide Duration** allows you to set how long each slide will be onscreen and how each slide fades in and out. Slides can be played in **Random Order** and the slideshow set to **Repeat** after playback.

Play/Preview Once you've set all the parameters of your slideshow, press **Play** to begin.

6 » PRINT MODULE

The Print module lets you set up your images ready for printing. This is achieved through a **Layout** panel on which images can be resized and rotated. As with the Slideshow module you can also overlay text to accompany your images. If you want to make life easier for yourself you can also use presets for different paper sizes and layouts, or save your own presets once you've created a print presentation style that you like. If you don't have a printer, you have the option of saving your layout as a JPEG on the **Print Job** options panel.

1) Template preview The thumbnail in template preview shows how your image will look on a page when printed.

2) Print template options Adobe supplies a number of template presets that can be applied to your prints, or you can save your own and apply them to future printing jobs.

3) Collections list Collections of images set up by you in the Library module.

4) Picture setup Select which photos are to be used to make a print.

5) Page Setup/Print Settings Page Setup allows you to choose your printer, and change the paper size and the orientation of the image on the page. Print Settings allows you to select your printer's color management settings and paper type.

6) Filmstrip Shows the current selection of images. By default it will show all the images in your catalog. However, you can

narrow the selection by creating a Collection.

7) Print option panels Choose how the printed page will be set up. Click on **Contact Sheet/Grid Layout** to print a single image or sheet of thumbnails of the same size. Or click on **Picture Package** to print out one image or create a sheet of thumbnails of different sizes.

8) Print editor view This is the print view, showing how the page will be printed. Multiple versions of the same image can be printed on the page. Any additions to the print, such as text, can placed here and positioned.

9) Print One/Print buttons When you've finished setting up your print, click on **Print One** to print one copy of your image, or **Print** to view the standard print dialog box for other options.

Your image will be displayed in the print editor view. Drag the edges of the image to resize it on the page.

Image Settings

Selecting **Zoom to Fill** will fill the entire image cell with your image. If necessary the edges of the image will be cropped to fit the image into the cell. If the portion of the photo that you want to see isn't displayed you can move it around the cell by left-clicking and dragging.

Selecting **Rotate to Fit** will rotate the image in the cell if necessary, to fit the largest image within the cell.

Repeat One Photo Per Page will repeat the same image when multiple rows and columns are added using **Layout**.

Stroke Border will add a line around your image. Use the slider to adjust the width of the line. The thicker the line, the smaller your image will print.

Layout

Specify the **Ruler Units** you prefer.

Alter the **Margins** on the page using the sliders. The images fit within the cells on the page. As you alter the margins your image will move around, and expand or shrink to fit on the page.

Specify how many times your image will repeat by using the **Page Grid** sliders. **Rows** specifies the number of times the image cells are repeated vertically, **Columns** how many times the cells repeat horizontally.

Alter the distance between each image cell using **Cell Spacing**.

Finally change the size of each image cell by altering the **Cell Size**. Select **Keep Square** if you want the cells always to be square.

Guides

The guides in the print editor view will help you visualize the final layout of the print. However, these guides can be turned off as desired, either all together by unchecking **Show Guides** or individually by unchecking the different options.

Overlays

If you have an identity plate set up (an option that allows you to personalize the Lightroom interface) you can overlay the identity plate information on your print by checking **Identity Plate** and altering the **Opacity** and **Scale** as required.

Page Options allows you to add **Page**

Numbers to your print, **Page Info**—the Print Sharpening setting, Profile setting, and printer information, and Crop Marks— guides that will help you to trim your photos after printing.

Photo Info is information such as exposure details or custom text, selected from the drop-down menu.

Font Size is the size of the printed characters shown in points (one point is roughly 1/72in.).

Chapter 7
ACCESSORIES

7 ACCESSORIES

You've bought your M9 and a few lenses but still that doesn't seem enough somehow. On the Leica and camera store web sites are accessories that look interesting and useful and... before you know it you have a drawer of unused equipment that seemed like a good idea at the time.

The key to buying optional accessories for your M9 is to consider carefully how you use the camera. If you're an occasional photographer, think about the cost of the equipment you are contemplating buying and how often you would realistically use it. If it's just one or two times a year then it may become difficult to justify. However, if it's something that will be used weekly then the equation will be different.

Accessories fall into two main categories, those that improve the ergonomics of your camera and those that genuinely help to expand the quality of your photography (with digital there's a third category, storage, but that is almost a necessity rather than an option). In an ideal world an improvement in image quality would take preference. But if your camera is easier to use you may find yourself shooting more, and as the saying goes, practise makes perfect.

» LEICA ACCESSORIES

Leica produces a number of accessories for the M-series of cameras that aid the photographic process. Each accessory is made to the same high standard as the cameras themselves.

› Viewfinder accessories

Although the Leica viewfinder is bright and easy to use, the following optional accessories are intended to enhance its overall performance.

Leica Viewfinder Magnifier 1.25 x & 1.4x

The magnifier is designed to aid framing of the subject when using lenses with a focal length longer than 50mm. The 1.25x version magnifies the central portion of the viewfinder by one quarter, the 1.4x by two fifths. This increases both the size of the bright line frame and focus guide, enabling you to see your composition and check focus more easily. The magnifier screws into the viewfinder ocular and has a leather carry case for safe storage when not in use.

Universal Wide-Angle Viewfinder M

The Leica Universal Wide-Angle Viewfinder M allows precise framing with the Leica Tri-Elmar-M 16-18-21mm lens fitted. The viewfinder has a parallax compensation dial to enable you to adjust for the focus distance set on the lens. Also featured is an illuminated spirit-level and a screw mount for diopter correction lenses.

Diopter correction lenses

If you're a glasses-wearer who wishes to look through the M9 viewfinder without your glasses on you can fit a correction lens to the viewfinder ocular. The Leica correction lenses are available in +- 0.5, 1, 1.5, 2 and 3 diopters. The viewfinder is set to -0.5 diopters already, so to order a correction lens add your spectacle lens diopter strength to -0.5 first (so if your prescription is +1.5 you would need a +2.0 correction lens).

Anglefinder M

Looking through the M9 viewfinder can be a problem if the camera is close to the ground. The Anglefinder M screws into the viewfinder ocular and allows you to look down at an angle of 45° through the viewfinder.

Handgrip M

The Handgrip M replaces the baseplate of your M9 and adds a useful ergonomic grip to the right side of the camera. The handgrip is available in black lacquer, silver, and steel-gray to match the model of M9 that you own. The handgrip is particularly useful with longer, fast lenses such as the Apo-Summicron-M 90mm f/2.

Leica Viewfinder Magnifier 1.25 x & 1.4x

Leica Viewfinder for 21/24/28 M-mount lenses

The basic viewfinder of the M9 does not allow you to compose with lenses wider than 28mm. This optional viewfinder allows you to compose with 21, 24, and 28mm lenses. The viewfinder is fitted into the flash hotshoe and is secured with a screw clamp. A simple thumbwheel changes the viewfinder to suit the desired angle of view. Available in either anodized black or silver to match your M9, the viewfinder comes with a leather case for protection.

Leica Viewfinder for 21/24/28 M-mount lenses

Leica Macro-Adapter M

The Leica Macro-Adapter M is used in conjunction with the Leica Macro-Elmar M 90mm lens so it can be used to create macro images. The adapter acts as an extension tube allowing focusing between 1.6 and 2.5ft (0.5 and 0.77m). The magnification factor with the adapter fitted is 1:6.7 to 1:3. Parallax error is avoided by a mechanism that corrects the problem with focusing at such short distances on a rangefinder camera.

Leica Macro-Adapter M

Camera Protector

It's all too easy to bash your M9, so Leica has designed a black soft-leather protector that wraps around the base and the sides of your camera. The various controls of the M9 are all still readily accessible.

» THIRD-PARTY ACCESSORIES

Few companies are as dedicated to improving the basic handling of the Leica M9 than Match Technical Services. The company provides a number of accessories for the M9 designed after talking to Leica owners and released after testing by photographers.

Thumbs Up

The Thumbs Up fits into the flash hotshoe of your M9 and helps you to get a more secure grip of the camera when handholding. Although it will vary from person to person, Match Technical believe that using a Thumbs Up will enable you to hold your camera at a two-stop slower

Leica M9 "Titanium"

Though not strictly an accessory, the special-edition M9 "Titanium" is the ultimate M9 to own. The unique body was created by the renowned Volkswagen automobile designer Walter de'Silva. As the name suggests, the camera is milled from titanium, with premium leather inserts. Only 500 units of this camera have been produced and they come with a special **LEICA SUMMILUX-M 35mm f/1.4 lens**, also milled from titanium. The cost to buy one of these desirable cameras? Almost five times the retail price of the standard M9.

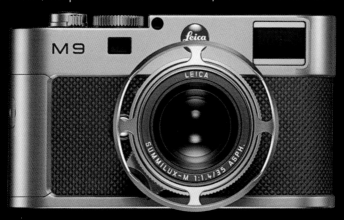

shutter speed than without. Thumbs Up is in constant development and different models have been released that cater for differences in hand size.

Beep, Boop, Bip, and Bug

These charmingly named devices screw into the cable-release thread in the M9 shutter-release button. By raising the height of the shutter-release they help to achieve a smoother action as you press down. Again, this has been designed to reduce the risk of camera shake.

Lens Coding Kit

Modern Leica lenses have a coded bayonet mount that allows the M9 to recognize the lens. With the Lens Coding Kit you can retrospectively add a code to a non-Leica or Leica lens that predates coding. The coding is not permanent and does not damage the lens.

Memory cards

The Leica M9 uses readily available SD (Secure Digital) memory cards up to a capacity of 2GB, or SDHC (SD High Capacity) cards up to 32GB.

As well as capacity, memory cards differ in their speed. This refers to the time it takes to read and write data between the card and the camera. Slow, low capacity memory cards are usually the cheapest; fast, high capacity cards the most expensive. Before you buy a memory card think about how you use your camera. If you require your M9 to be ready to shoot almost immediately after image capture you will require a fast card. If your shooting style is more leisurely, a slower but higher capacity card may be the better choice.

Another factor to consider is how many memory cards you need. The larger the card, the more images you can store on it. However, this could be devastating if you lose that card. Using a number of smaller capacity cards will require more work to swap around and download, but losing one card will not be so traumatic.

Other storage devices

If you travel you will invariably require a storage device to download your images to "on the go." A laptop is one way to achieve this, with the advantage that images can be review and edited, and with a suitable wi-fi connection, emails can be checked to keep in touch with home.

There is also a variety of storage devices specifically for storing images. These are far smaller devices than laptops but usually still have an LCD screen for reviewing images once they have been downloaded.

Tablet devices, such as the Apple iPad, combine the best of both worlds: with a suitable "app" they can approach the functionality of a laptop, with the reasonably diminutive size of an image storage device.

© Apple Inc.

APPLE iPAD　　　　　　　　　　　　　**«**
Image storage on the move, in tablet form.

» FILTERS

A filter is a piece of glass, plastic, or optical resin that changes the quality of the light that passes through it. There is a wide variety of filters available, some subtle, some not so subtle. The effect of some filters can be mimicked in Lightroom, but others, such as a polarizer, are unique and cannot be replicated in software.

Adding a filter will affect the ultimate quality of your images. The better the optical qualities of the filter, the less noticeable this drop in image quality will be. Even so, it is not advisable to stack too many filters onto your lens.

Attaching filters

There are two different systems for attaching a filter to the front of your M9 lens. The first type is the circular screw-in filter. The filter screws into the thread on the front of your lens. Most filter types come in screw-in form, though some filters, such a ND-graduates *(see page 218)* are less useful this way.

A quick look at the filter thread-size column in the table of *page 152* will show you that there is no standard filter thread size. This is the one drawback to circular screw-in filters. If you have a range of lenses you potentially have to buy the same filter for each of the different lenses. One simple solution is to buy adapter rings for your filters. Buy a filter for the biggest thread size in your lens collection, and then buy adapter rings that allow you to fit that filter to the lenses with smaller thread sizes.

ND FILTER ⌃
This 10-stop ND filter is a screw-in type. Because it has a large 77mm thread, I need to use a step-up ring to attach it to most of my lenses.

Filter holders

A more flexible way of using filters is to use a filter holder system. Filter holders are usually made of plastic and have slots into which rectangular or square filters can be fitted. Some filter holder systems also have a ring onto which a polarizer can be screwed and allowed to rotate *(see page 216)*. Inexpensive adapter rings fitted to your lenses enable you to attach the same filter holder, and therefore the same filters, to each lens.

There are several manufactures of filter holder systems, such as Cokin and the British company, LEE. The range of filters available for both systems is extensive and is further increased by compatible filters produced by other manufacturers.

UV and skylight filters

Ultraviolet light can cause an excessive blue cast to your images. This is particularly noticeable with photos shot at high altitude. A UV filter will help to cut down this blueness and also reduce the effects of haze. A skylight filter has a similar effect but is slightly pink in color and so helps to add warmth to an image.

The color correcting aspect of these two filters can now be tackled in Lightroom, so an argument could be made that they are no longer necessary. However, as they do not filter much visible light they can be safely left fixed to your lens without affecting exposure. For this reason, some photographers use them to protect the front element of the lens. The idea is that replacing a scratched filter is better having to replace a scratched lens.

© LEE Filters

COLORED FILTER SET «
LEE's Sky Filter Set will put a different complexion on your images.

Neutral density filters

The M9 can be set as low as ISO 80. However, this is at the cost of reduced dynamic range and the increased likelihood of losing detail in the highlights and shadows. The true base ISO of the M9 should more properly thought of as ISO 160. This is "fast," particularly in comparison with fine-grained slide film.

Therefore it can be difficult to achieve a slow shutter speed or wide aperture in all but the lowest light levels.

Neutral Density (ND) filters cut down the amount of light that passes through them—in effect they are sunglasses for cameras. This allows you to effectively lower the ISO of your camera and open up the possibility of using a wider range of shutter speeds and apertures. ND filters come in a variety of strengths, from 1 stop up to 10 stops, both as screw-in and filter holder types.

Effects filters

An effects filter is one that adds something to the image that wasn't in the original scene. This includes filters such as soft-focus, star filters, and strongly colored filters that add an overall cast to your images. Because the results of effect filters are so striking and easily recognized it is important not to overuse them. Used sparingly and judiciously they will retain their effectiveness. Use them constantly and you run the risk of your photography becoming clichéd.

LONG EXPOSURE **«**
The use of a three-stop ND filter enabled me to achieve a 15 sec. exposure that would have been impossible otherwise.

› Polarizing filters

Bring to mind a photograph with a deep blue sky and billowing clouds and it's fairly likely that a polarizer was used to create the effect.

Light rays that have been reflected off non-metallic surfaces are randomly scattered in a variety of directions. This scattering reduces contrast and color saturation. A polarizer works by only letting in light rays from one plane of scattering. All polarizers can be turned, and in turning you choose what light rays are filtered and which are not and so adjust the strength of the polarizing effect.

Polarizers work on a wide variety of non-metallic surfaces, from water to glossy paint to foliage. Using a polarizer will help you to see through the "glare" caused by light ray scattering to record the true colors of the subject. The optimum angle for this effect is when the polarizer is at approximately 35° to the reflective surface. Use a polarizer with blue skies at 90° to the sun and the sky will become a more intense blue.

There are two types of polarizers, circular and linear (which do not refer to the shape, rather how the polarizer filters the light). Circular polarizers, which tend to be more expensive than linear, are only needed for cameras with autofocus systems and so are not required for the M9.

Because a polarizer blocks a certain amount of light that passes through it you will need to adjust your exposures to compensate if shooting in manual. Typically about 1.5 to 2 stops compensation is required.

DOWN IN THE VALLEY »
I used two filters for this image. The first, a two-stop ND-graduated filter, allowed me to balance the exposure of the lit top half of the image with the less well-lit bottom. The second filter was a polarizer, which deepened the blue of the sky and river, and also usefully lengthened the shutter speed.

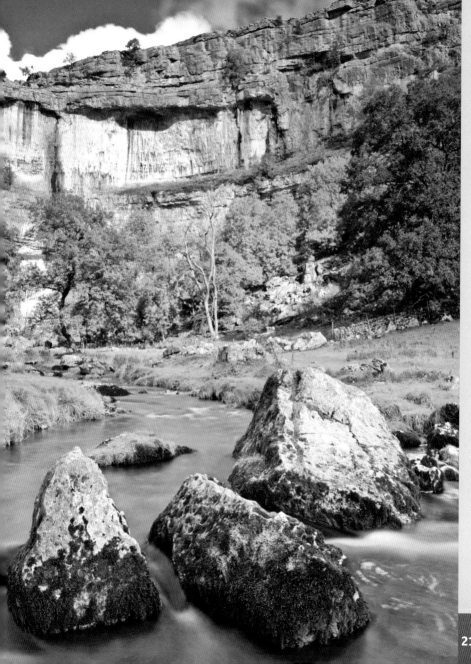

Nature does not often oblige photographers with even brightness levels across an entire scene. The problem is frequently encountered in landscape photography, since the sky is often brighter than the foreground. If the difference is sufficiently great you will not be able to expose for one, without losing detail in the other.

ND-graduate filters are used to even out the exposure in these situations. The bottom half of an ND-graduate filter is clear, the top half is slightly opaque. The stronger the filter, the more opaque the top half. The greater the difference in the light levels, the stronger the ND-graduate you would use. As with ND filters, the strength of ND-graduates is measured in stops. ND-graduate filters are sold as either hard or soft. This refers to how sudden the transition from clear to opaque is. Hard is a relatively abrupt transition, soft is more subtle and attenuated.

The composition of your image will determine where the lighter part of the scene blends to the darker. This is the point where the clear-opaque transition zone on the filter should be placed. Because of this ND-graduate filters are easier to use when they can be moved up and down in a filter holder, rather than fixed as they would be if screwed to the front of a lens.

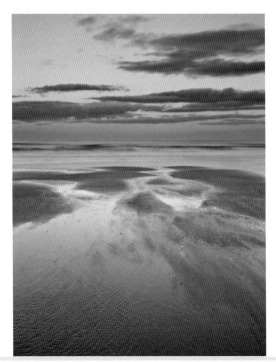

HEAVY SKY **«**
Use too strong an ND-graduate and the balance of exposure is shifted in the other direction. This sky has been darkened too far and so looks false.

› Using filters with a rangefinder

Filters that do not require precise positioning for their effect are simple to use with the M9. However, filters such as polarizers or ND-graduate filters need to be aligned exactly for maximum effect. Because you do not look through the lens on an M9 this can be a tricky prospect. Fortunately with a bit of ingenuity and thought this problem can be overcome.

Polarizer

If your polarizer is mounted to a filter holder, take the holder off the lens and adjust the filter with it held close to your face. Once you've achieved the correct amount of polarization, replace the filter holder on the lens in exactly the same orientation, without turning it.

If you use a screw-in polarizer, carefully mark one part of the turning ring with a hardwearing spot of paint. Looking through the polarizer, turn it until you've achieved the correct amount of polarization. Note where the paint spot is and then screw the polarizer to the lens. Rotate the ring until the paint spot is in the same position. It helps to think of the paint spot as being at a particular hour on the clock when it comes to memorizing its position.

ND-Graduate

Mark the exact center of your filter holder on both sides with a hardwearing spot of paint. Place the filter holder on your lens and now make marks where the glass of your lens comes to, both top and bottom, on your filter holder (if you have multiple lenses use different colors for each lens).

Look through the viewfinder of the M9 and judge where the transition zone should be. With the filter holder in your hands, use the marks you made to position the ND-graduate so that it matches where you've judged it should be placed.

LAST LIGHT «
Without the use of a 3-stop ND-graduate filter I would not have been able to hold detail in the foreground without the sky burning out.

» SUPPORTING THE CAMERA

To make photographs that are completely sharp, especially when working with slow shutter speeds, it is vital that the camera is kept completely still. The conventional way to do this is by using a tripod.

Many people resist using a tripod, believing that it will somehow hamper their spontaneity and creativity, because it takes time to set up the camera on the tripod. But the opposite is often the case: you might find that in being forced to slow down, you take more time to consider your subject-matter and the shot you are setting up, leading to more pleasing results.

There are several things to think about in order to choose a tripod that will best suit your needs. If you intend to carry your tripod long distances on foot, weight will be a consideration. Weight adds stability to a tripod, but buy one that is too heavy and you will be more reluctant to use it.

Modern carbon fiber models, though more expensive than their metal counterparts, are sturdy and yet surprisingly light to carry. If you work in a portrait studio weight will matter less but height and the type of head fitted may be more important.

In considering the best type of feet for your tripod, again you need to consider where you will be using it. Some tripods have spiked feet and others flat rubber feet. Spiked feet add stability on soft ground, but rubber feet are much more suitable in situations where spiked feet might cause damage, such as on priceless cathedral floors!

The possible leg-angles of the tripod are also important. The wider the angle that can be achieved, the more stable the tripod will be. In addition, a wider variety of leg angles gives a greater potential for creativity in your shot-making.

There is a wide range of mini and tabletop tripods available. The Leica M9 is relatively lightweight in comparison to a DSLR, so is better suited to these smaller offerings. Mini tripods are ideal for air-travelers, since they won't break weight restrictions when stored in hold-luggage.

Benro Carbon Fiber Tripod C0681TB Travel Angel

› Alternative supports

Apart from tripods, there is a myriad of other choices for keeping your camera stable and your images sharp.

As the name suggests, monopods have a single, telescopic leg. They have the advantage of being very lightweight and easy to carry, and are also useful when you need to move around more quickly and easily than a tripod would allow. Some monopods can be used as a walking pole with the camera mounting screw concealed within the design.

Other supports available include clamps and suction cups, with integral camera mounting screws, which can be attached to a variety of surfaces.

The simplest form of camera support is a small beanbag. These can bought commercially or even made at home. The beanbag has to be big enough so that the base of the M9 is fully supported. It can be used on any stable flat surface and will stop the base of your camera getting scratched.

Joby Gorillapod Green

Stealth Gear Double Bean Bag

© Stealth-Gear.com

Chapter 8
CARE

8 CARE

The Leica M9, in common with all digital cameras, is a delicate piece of equipment, which can be easily damaged if exposed to hostile conditions. Dust, moisture, and extreme temperatures can all have a detrimental effect on the camera's operation. However, by taking a few simple precautions you should receive optimum performance from the camera, and prolong its useful life.

» DUSTY CONDITIONS

Dust and sand can be particularly dangerous for camera, lenses, and memory cards, and in extreme cases may even cause irreparable damage.

When you are working in these conditions, it is a good idea to keep your camera in your camera bag until you actually wish to use it.

The camera is particularly vulnerable when you are changing lenses, since dust can enter the body through the lens mounting. This can also damage the lens elements. When changing lenses in these conditions, try to find a sheltered spot, to limit the camera's exposure to any wind-borne particles.

When you are not using the camera, it is good discipline to always attach a lens or body cap. If you are attaching the body cap, you should take care to remove any dust from it beforehand.

BEACH SCENES «
Great care must be taken with your camera at the beach. It's all too easy to get sand in your camera bag without realizing. Never keep your bag open if you lay it on the ground as sand can easily be kicked in.

› HOT & HUMID CONDITIONS

Exposure to extreme levels of heat can cause a great deal of damage to the camera. High temperatures may cause the camera body to become distorted, resulting in malfunction, and the lubricating oils that enable the camera to operate smoothly may cease to be effective, resulting in costly damage. It is, therefore, vitally important to protect your camera from intense heat.

Direct sunlight can be very destructive:

be careful never to leave the camera lying around in the full sun without the protection of a lens cap. Should the lens be pointing directly at the sun, the effect on the camera will be the same as that of focusing the sun's rays through a magnifying glass.

You should also avoid leaving the camera in a hot place, such as a car on a very sunny day. The heat that can build up in such a situation can be very intense, and again, this can do a lot of avoidable damage to the camera.

One way of protecting the camera in this situation is to use an insulated camera bag. If you do not have one, a food cool box can be equally effective. Even wrapping the camera in a light-colored fabric will afford it a degree of protection.

If you are using your camera in hot, humid conditions, there are other risks. The potential build-up of condensation can have a detrimental effect on the camera and on your images. Should you find that condensation has formed on the camera, switch the camera off and leave it

KEEPING COVERED ≪
Protecting your head and neck is vital when out in the sun for any length of time.

to stand at room temperature for at least an hour. This should cause the condensation to evaporate.

In humid conditions, you may find it helpful to store your camera in an airtight container or plastic bag, with a sachet of silica gel. This absorbs the moisture and so prevents condensation building up on the camera itself.

› Protecting yourself in hot conditions

It is not just your camera that needs to be protected when you are photographing in particularly hot conditions. You should also consider your own safety and comfort, and plan accordingly.

Light, loose-fitting clothing will keep you as cool as possible. It is also important to keep your head covered, and a wide-brimmed hat will also help you to feel cooler. Apply a high factor sunscreen and be sure to carry plenty of drinking water.

Finally, remember that very sunny conditions seldom result in the finest photography. The quality of the light at dawn and sunset are far more attractive and result in much better photography, with more interesting skies and an absence of hard shadows. With this in mind, it could be better for you to avoid the heat of midday, and do your photography in the cooler conditions at either end of the day.

DESERT LIGHT　　　**《**
Avoiding the heat of the midday sun also means avoiding the less flattering light at that time of day.

COLD CONDITIONS

Extreme cold can badly affect the performance of your camera. However, a few simple precautions should mean that you will be able to enjoy your outdoor photography without fear of your precious camera malfunctioning.

Batteries are particularly vulnerable to the cold, and extremely low temperatures can cause their performance to fall off considerably. It is a good idea to guard against this eventuality by carrying a spare, fully charged battery with you as a backup. Carry this where it can be kept warm, such as in your jacket inside pocket.

The performance of the camera in low temperatures will also be improved if you are able to keep it warm. Try to store it in your camera bag, rather than carrying it exposed to the elements, when you are not using it. You could even wrap it in a layer of insulation, such as a spare hat or a scarf.

Apart from poor battery performance, other symptoms that indicate that the camera is too cold include a darkening of the monitor and a general slowing down of its operation.

SIMPLIFICATION **«**
One benefit of snow is that it simplifies the landscape by covering distracting details. The color palette is often very monochrome which lends itself to a graphic approach to composition.

As well as protecting your camera from the cold, it is vital for your health, as well as for your enjoyment of your photography, to protect yourself in conditions of extreme cold.

The best way of ensuring that you are comfortable, and not distracted by the cold, is to wear a number of lighter layers of clothing, rather than one single, bulky layer. Each separate layer will trap your own body heat and insulate you from the cold.

A light wool layer is ideal next to the skin. Merino wool is particularly good, being soft and fine-textured. A layer of fleece provides the perfect middle layer. It is light and provides a good level of insulation, even when it gets wet.

If conditions are especially cold, you may find that a down jacket makes an invaluable addition to your wardrobe. This will provide an extremely efficient thermal layer, and has the added advantage that it packs down to a very small size, making it easy to carry with you.

One layer that you should always consider carrying with you when you are photographing outdoors, especially in changeable or unpredictable weather conditions, is a light waterproof garment. This can act as another insulting layer, as well as protecting you from rain and snow.

KEEPING WARM «
Photography is supposed to be enjoyed not endured. If you're cold you're more like to give up for the day and miss photographic opportunities.

» WET CONDITIONS

Water can cause the camera to malfunction, and in some cases even cause permanent damage to the camera itself, or to the memory card. When photographing in wet weather, or beside the sea, a river or a swimming pool, you should take care to avoid allowing the camera to get wet.

If you need to change lenses while photographing in rain or snowy weather, shield the camera as well as you can, perhaps under your coat, to prevent water from getting into the camera or onto the fittings.

Some makes of camera bag have a special rain cover, which it is possible to fold away when not in use. This has the advantage of keeping all of your equipment safe and dry when you are not using it.

There are some makes of bag that actually have two separate covers; one cover fits over the top of the bag, the other wraps around the whole bag. The second cover is also useful for keeping your camera bag safe if you wish to put it down on damp ground.

Salt water can be particularly damaging to the camera. If you are taking photographs on the beach and the camera does get wet, clean it with a soft cloth, dampened with tap water. Then dry it thoroughly with a soft, dry cloth.

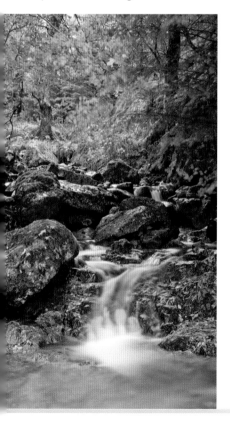

WET DAYS IN THE WOOD «
Woodland is a great location to go to when the weather is inclement.

Wet weather should not be an obstacle to your enjoyment of your photography. The key to success is in both being properly prepared, and in choosing your subject-matter with care.

Never take unnecessary risks. Hilly or mountainous areas can be very hazardous in poor weather. If you must venture into such areas in bad conditions, be sure to let someone know where you will be going, and at what time you expect to return. Carry a fully charged cell phone with you if you can.

It is always a good idea to carry a light waterproof jacket, even in good weather, in case of rain showers. Another useful addition to your camera kit could be a small, collapsible umbrella. This is useful not only for helping to keep you dry in a shower, but also for sheltering smaller, macro subjects from rain and wind.

In very rainy conditions, where the weather might seem to make it impossible to do any photography outdoors, there may still be possibilities. Instead of choosing wide-open vistas, where you will be exposed to the elements, why not consider

SUN ROOF ⌄
Raindrops on glass make for great abstract images, particularly when they settle on the sunroof of your car!

taking refuge within an area of woodland? This will not only give you shelter from the worst of the weather conditions; the soft-light conditions which accompany rainy weather are ideal for capturing woodland scenes and macro detail.

› Water

Should the worst happen and your M9 is drenched, try to get it home as quickly as possible. If the camera has been dropped in salt water clean, remove the battery, and dry it as best you can. Contact your local Leica repair center for advice as soon as possible. Salt is corrosive and will damage your camera very quickly without immediate attention.

Fresh water—though still not an ideal medium for an unprotected camera to be in—is less damaging. As with salt water contact your local Leica repair center for advice. To help dry the camera, remove the battery, get a big bowl and place your camera (with the lens cap or lens fitted—you don't want rice inside the camera) carefully in the bowl. Fill the bowl with rice so that the camera is entirely covered. The rice will start to absorb any water from the camera. This may take a day or so. When this is done clean up your camera, replace the battery and switch on to test.

» OTHER CARE TIPS

• Keep the flash contacts clean with a pencil eraser. Grease on the contacts can cause a signal failure between the flash and the camera

• Keep a small packet of silica gel in your camera bag. This will help to absorb any excess moisture from the interior of the bag.

• Keep your memory cards away from magnetic sources. Loudspeakers (unless shielded) and microwaves generate magnetic fields. Don't store memory cards in hot places, don't keep them in a car for instance. It doesn't take much direct sunshine for a car to heat up.

• Keep the lens mount cap on the camera whenever a lens is removed. Never leave the lens mount open to the elements for anything other than a short period of time.

Warning!

Should the worst happen and your Leica stops functioning, it should be sent to an authorized repair center only (see page 238). *Bear in mind that the Leica warranty will be immediately invalidated if you use an unofficial repair service.*

8 » CARE FOR LENSES

Leica lenses are rightly regarded as the sharpest available for any camera system and also some of the most expensive. It makes sense, therefore, to protect your investment and to take as much care of them as possible.

The glass elements of a lens are vulnerable to scratching and so care must be taken when cleaning. If there are visible specks of dust on them, hold the lens upside down and use an air blower to remove them.

Rain spots, fingerprints or other grease marks can increase the likelihood of flare occurring. These should be cleaned off carefully with a dedicated lens cloth—not with a handkerchief or other handy bit of material. Without pressing too hard, move the cloth in a circular motion around the lens surface. If a mark is particularly stubborn use a lens-cleaning fluid or distilled water.

Many photographers like to attach a skylight or UV filter to their lenses. The theory is that if the lens is dropped the filter will protect the lens glass from being smashed—at the cost of an easily replaceable filter. These filters do not reduce the amount of light entering the lens and so do not affect exposure. However, placing any filter between the scene and the camera's sensor may have

a slightly detrimental effect on the final image quality.

Care should also be taken when cleaning the LCD screen on the rear of the M9; tough though it is it can be scratched. As with lenses, clean any dust off with an air blower and then wipe with a dedicated soft cloth only. Commercially available film can be bought to apply over the screen that will protect it from scratches with only a marginal loss of clarity.

GIOTTO'S ROCKET BLOWER ⌃
A good size blower can be used to clean dust from lenses and the M9's sensor.

Cleaning the sensor

Dust will invariably build up on the sensor of your M9. The dust will most easily be seen in areas of even tone, such as clear sky, when you've used a small aperture. The M9 does not have an automatic dust-cleaning system and so dust, when it appears, must be either removed physically from the sensor or cleaned-up digitally in post-production.

The simplest way to clean the sensor is to use a low-pressure air blower to blow the dust particles from the sensor surface. To do this the shutter must be kept open using the sensor cleaning option on the Main menu.

Note:
Leica will clean your M9 sensor for you but you will be charged for this service.

If the battery charge is less than 60% you will not be able to activate sensor cleaning and the message **Attention—Battery too low for sensor cleaning** will be displayed on the LCD.

If the battery charge drops below 40% during the cleaning process the message **Attention—Battery low Switch off camera** will be displayed on the LCD and a continuous tone will be played. Remove the blower from the sensor chamber and switch off your camera.

1) Press the MENU button and select **Sensor cleaning**. On the submenu highlight **Yes** and press SET. Press the shutter-release button down fully.

2) Remove the lens or body cap from your M9.

3) Hold the camera upside-down with lens mount facing downward.

4) Insert the tip of your air blower carefully into the sensor chamber without touching the sensor itself. Blow air over the sensor until you think the dust has been removed.

5) Turn off your M9. Replace the lens or body cap.

» GLOSSARY

Aberration An imperfection in the image caused by the optics of a lens.

AE (autoexposure) lock A camera control that locks in the exposure value, allowing an image to be recomposed.

Angle of view The area of a scene that a lens takes in, measured in degrees.

Aperture The opening in a camera lens through which light passes to expose the sensor. The relative size of the aperture is denoted by f-stops.

Bracketing Taking a series of identical pictures, changing only the exposure, usually in half or one f-stop (+/-) differences.

Buffer The in-camera memory of a digital camera.

Cable release A device used to trigger the shutter of a tripod-mounted camera from a distance to avoid camera shake.

CCD (Charged-Coupled Device) A microchip consisting of a grid of millions of light-sensitive cells—the more cells, the greater the number of pixels and the higher the resolution of the final image.

Center-weighted metering A way of determining the exposure of a photograph, placing importance on the lightmeter reading at the center of the frame.

Chromic aberration The inability of a lens to bring spectrum colors into focus at a single point.

Color temperature The color of a light source expressed in degrees Kelvin (°K).

Compression The process by which digital files are reduced in size.

Contrast The range between the highlight and shadow areas of an image, or a marked difference in illumination between colors or adjacent areas.

Depth of field (DOF) The amount of an image that appears acceptably sharp. This is controlled by the aperture: the smaller the aperture, the greater the depth of field.

Diopter Unit expressing the power of a camera lens.

Dpi (dots per inch) Measure of the resolution of a printer or scanner. The more dots per inch, the higher the resolution.

Dynamic range The ability of the camera's sensor to capture a full range of shadows and highlights.

Evaluative metering A metering system whereby light reflected from several subject areas is calculated based on algorithms.

Exposure The amount of light allowed to hit the sensor, controlled by aperture,

shutter speed, and ISO. Also, the act of taking a photograph, as in "making an exposure."

Exposure compensation A control that allows intentional over- or underexposure.

Fill-in flash Flash combined with daylight in an exposure. Used with naturally backlit or harshly side-lit or toplit subjects to prevent silhouettes forming, or to add extra light to the shadow areas of a well-lit scene.

Filter A piece of colored, or coated, glass or plastic placed in front of the lens.

Focal length The distance, usually in millimeters, from the optical center point of a lens element to its focal point.

fps (frames per second) A measure of the time needed for a digital camera to process one image and be ready to shoot the next.

f-stop Number assigned to a particular lens aperture. Wide apertures are denoted by small numbers such as f/2; and small apertures by large numbers such as f/22.

Histogram A graph used to represent the distribution of tones in an image.

Hotshoe An accessory shoe with electrical contacts that allows synchronization between the camera and an accessory such as a flashgun.

Hotspot A light area with a loss of detail in the highlights. This is a common problem in flash photography..

Incident-light reading Meter reading based on the light falling on the subject.

Interpolation A way of increasing the file size of a digital image by adding pixels, thereby increasing its resolution.

ISO (International Organization for Standardization) The sensitivity of the sensor measured in terms equivalent to the ISO rating of a film.

JPEG (Joint Photographic Experts Group) JPEG compression can reduce file sizes to about 5% of their original size.

LCD (Liquid crystal display) The flat screen on a digital camera that allows the user to compose and review digital images.

Macro A term describing close-focusing and the close-focusing ability of a lens.

Megapixel One million pixels equals one megapixel.

Memory card A removable storage device for digital cameras.

Noise Colored image interference caused by stray electrical signals.

Pixel Short for "picture element"—the smallest bits of information in a digital image.

Predictive autofocus An autofocus system that can track a moving subject.

RAW The file format in which the raw data from the sensor is stored without permanent alteration being made.

Red-eye reduction A system that causes the pupils of a subject to shrink, by shining a light prior to taking the flash picture.

Remote switch A device used to trigger the shutter of a tripod-mounted camera at a distance to avoid camera shake. Also known as a "cable release."

Resolution The number of pixels used to capture or display an image.

RGB (red, green, blue) Computers and other digital devices understand color information as combinations of red, green, and blue.

Rule of thirds A rule of thumb that places the key elements of a picture at points along imagined lines that divide the frame into thirds.

Shutter The mechanism that controls the amount of light reaching the sensor, by opening and closing.

Spot metering A metering system that places importance on the intensity of light reflected by a very small portion of the scene.

Tele-convertor A lens that is added to the main lens, increasing the effective focal length.

TTL (through-the- lens) metering A metering system built into the camera that measures light passing through the lens at the time of shooting.

TIFF (Tagged Image File Format) A universal file format supported by virtually all relevant software applications. TIFFs are uncompressed digital files..

USB (universal serial bus) A data transfer standard, used by the M9 when connecting to a computer.

Viewfinder An optical system used for composing, and for focusing the subject.

White balance A function that allows the correct color balance to be recorded for any given lighting situation.

Wide-angle lens A lens with a short focal length and a wide angle of view.

» USEFUL WEB SITES

LEICA

Leica USA
http://us.leica-camera.com

Leica UK
http://uk.leica-camera.com

Leica Germany
http://de.leica-camera.com

Leica France
http://fr.leica-camera.com

CONTACT LEICA

Leica USA & Canada
Leica Camera Inc.
1 Pearl Ct, Unit A
Allendale, New Jersey 07401
repair@leicacamerausa.com

Leica UK
Leica Camera Ltd
34 Bruton Place
London
W1J 6NR
owner@leica-camera.co.uk

Leica Germany
Leica Camera AG
Leica Customer Service
Solmser Gewerbepark 8
35606 Solms
cs@leica-camera.com

Leica France
Procirep
14-16 Bld Auguste Blanqui
75013 Paris
procirep@wanadoo.fr

OTHER MANUFACTURERS

Voigtländer
http://www.voigtlaender.com

Carl Zeiss
http://www.zeiss.de

Match Technical
http://matchtechnical.com

GENERAL

David Taylor
Landscape and travel photography
www.davidtaylorphotography.co.uk

Digital Photography Review
Camera and lens review site
www.dpreview.com

Photonet
Photography Discussion Forum
www.photo.net

EQUIPMENT

Adobe
Photographic editing software such as
Photoshop and Lightroom
www.adobe.com

Apple
Hardware and software manufacturer
www.apple.com

PHOTOGRAPHY PUBLICATIONS

**Photography books & Expanded Camera
Guides**
www.ammonitepress.com

Black & White Photography magazine
Outdoor Photography magazine
www.thegmcgroup.com

» INDEX

LEICA M9
THE EXPANDED GUIDE
SYMBOLS USED

Icon	Symbol	Meaning
O	Setting dial	
◀	Direction button Up	**S** — Single advance
▶	Direction button Down	**C** — Continuous advance
▼	Direction button Left	**Auto** — Auto white balance
▲	Direction button Right	☀ — Sunshine white balance
↻	Self-timer mode	☁ — Cloudy white balance

	
⌂	Shadow white balance
☀	Tungsten (incandescent) white balance
⚡	Flash white balance
⚡	Flash—viewfinder LED
⬚	Manual setting
Kelvin Setting	Adjustable color temperature value
⎕	Protect mode

SNAPSHOT MODE—Flashing red symbols

	
●	Correct exposure
▼	Risk of overexposure
▲	Risk of underexposure
▼	Overexpose
▲	Underexpose
☲1	Fluorescent 1 (warm lighting)
☲2	Fluorescent 2 (cool lighting)

Leica SF 24D

ISO	F2.0	f/2.8	f/4	f/5.6	APERTURE f/8	f/11	f/16
160	14.5m 47.6ft	10.35m 34ft	7.24m 23.76ft	5.18m 16.99ft	3.62m 11.88ft	2.64m 8.66ft	1.81m 5.94ft
200	16.97m 55.68ft	12.12m 39.76ft	8.49m 27.85ft	6.06m 19.88ft	4.24m 13.91ft	3.09m 10.14ft	2.12m 6.96ft
400	24m 78.74ft	17.14m 56.23ft	12m 39.37ft	8.57m 28.12ft	6m 19.69ft	4.36m 14.30ft	3m 9.84ft
800	33.94m 111.35ft	24.24m 79.53ft	16.97m 55.68ft	12.12m 39.76ft	8.49m 27.85ft	6.17m 20.24ft	4.24m 13.91ft
1600	48m 157.48ft	34.29m 112.50ft	24m 78.74ft	17.14m 56.23ft	12m 39.37ft	8.73m 28.64ft	6m 19.69ft

Leica SF 58

ISO	F2.0	f/2.8	f/4	f/5.6	APERTURE f/8	f/11	f/16
160	35m 114.38ft	25m 82.02ft	17.05m 55.94ft	12.5m 41.01ft	8.73m 28.64ft	6.37m 8.66ft	4.38m 14.37ft
200	41.01m 134.55ft	29.29m 96.10ft	20.51m 67.29ft	14.65m 48.06ft	10.25m 33.63ft	7.46m 24.48ft	5.13m 16.83ft
400	58m 190.29ft	41.43m 135.93ft	29m 95.14ft	20.71m 67.95ft	14.5m 47.57ft	10.55m 34.61ft	7.25m -23.79ft
800	82.02m 269.09ft	58.59m 192.22ft	41.01m 134.55ft	29.29m 96.10ft	20.51m 67.29ft	14.91m 48.92ft	10.25m 33.63ft
1600	116m 380.58ft	82.86m 271.85ft	58m 190.29ft	41.43m 135.93ft	29m 95.14ft	21.09m 69.19ft	14.5m 47.57ft